Rauschenberg
Reflections and Ruminations

Museum of Outdoor Arts
Englewood, Colorado

This catalog was created to accompany the exhibition
at MOA's indoor galleries. February 24–June 13, 2020

Published by the Museum of Outdoor Arts in
conjunction with its presentation of the exhibition:
Rauschenberg: Reflections and Ruminations
February 24–June 13, 2020

Exhibition and catalog produced for the Museum of Outdoor Arts
by Dan Jacobs Associates. Curated by Dan Jacobs and Sarah Magnatta, PhD

Introduction by Cynthia Madden Leitner
Essays by Dan Jacobs, Hiroko Ikegami, PhD, Sarah Magnatta, PhD, Sienna Brown, PhD
Extended captions by Sarah Magnatta and Dan Jacobs

Editors: Rupert Jenkins and Dan Jacobs

Catalog Design: Mary Junda

Printing: OneTouchPoint, Denver

ISBN 978-0-578-62379-5

Cover and this page: *Pegasits,* 1990 (details). Acrylic, fire wax and chair on stainless steel.
Photograph by William O'Connor

Supported in part by:

Founded in 1981, the Museum of Outdoor Arts (MOA) is a forerunner in the placement of
site-specific sculpture in Colorado. Its art collection is located in public locations throughout
the Denver metropolitan area. Designed as a "museum without walls," MOA integrates
inspiring arts into the community and implements its mission of "Making Art a Part of
Everyday Life." MOA owns and operates Fiddler's Green Amphitheatre in collaboration with
its tenant, AEG Presents, and features more than 150 pieces in its permanent collection. MOA
also curates indoor galleries and hosts world-class art exhibitions and educational programs.

MOAonline.org

MOA Indoor Gallery
1000 Englewood Parkway
Englewood, CO 80110

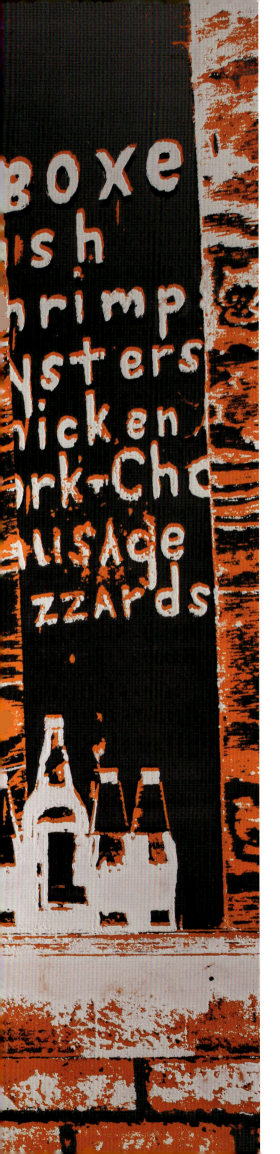

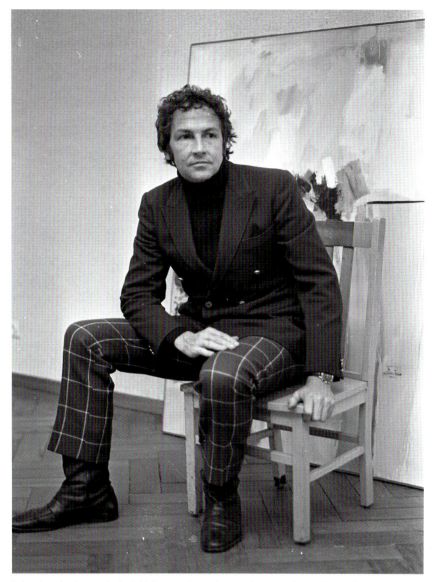

Robert Rauschenberg at the Stedelijk Museum, Amsterdam, April 1968, seen here with one of his works. Photo source: Nationaal Archief, CC0. Photograph by Jac de Nijs / Anefo

Contents

Director's Foreword

Cynthia Madden Leitner

I met Robert Rauschenberg at his home on Captiva Island, Florida in the early 1980s. My parents, who were long-time residents of Florida and friends of his, introduced us. What struck me at first was his charismatic aura, along with his wry sense of humor. These explain why many of his associates and friends discuss the man before talking about his art. As it goes, a bit of familiarity with the artist and his art (the paintings, constructions and "combines," photographs, and prints) provides a more intimate insight into the meaning behind the work. The added gift of storytelling enlightens the process, too.

Our title, *Reflections and Ruminations*, refers both to the titles of certain works presented and to the highly polished "reflective" metal surfaces with applied silkscreen images, which become literally interactive through reflection of the viewer. Rauschenberg created the *Rumination* pieces with Universal Limited Art Editions (U.L.A.E.) in the 1990s. The series of photographic montages were assembled as memoirs of people who played a role in his life, milestone events, and places of personal importance and historic value, creating a more metaphorical series of "reflections."

This exhibit has taken five years to develop and present. The initial planning in 2015 was made possible by my father, John Madden, who offered pieces from his collection and introduced me to the private collector who generously loaned the largest number of pieces in the MOA exhibition. During the last two years MOA is grateful to have worked with curator Dan Jacobs and Associates to culminate the final exhibition and fulfill the initial vision. An exhibition of the caliber of "Reflections and Ruminations" requires a talented and exemplary staff. Thanks to the staff at MOA, the exhibition has come to fruition.

It is an honor for MOA to share over 50 iconic pieces by the master with the community by means of the first major solo exhibition of Robert Rauschenberg's work in Colorado since 1981. We are profoundly appreciative of the institutional and private collectors, including those who wish to remain anonymous, for lending works to this exhibition.

Anonymous Collectors
Lily Appelman & Eugene Heller
Dr. Carol Goldstein and Henry Goldstein
CU Art Museum, University of Colorado Boulder
Madden Collection at the University of Denver
Universal Limited Art Editions

Autobiography, 1968. Offset lithograph, three sheets, 66¼ x 48¾ in. each

Opposite: *Autobiography*, 1968 (sheet 1), 66¼ x 48¾ in.

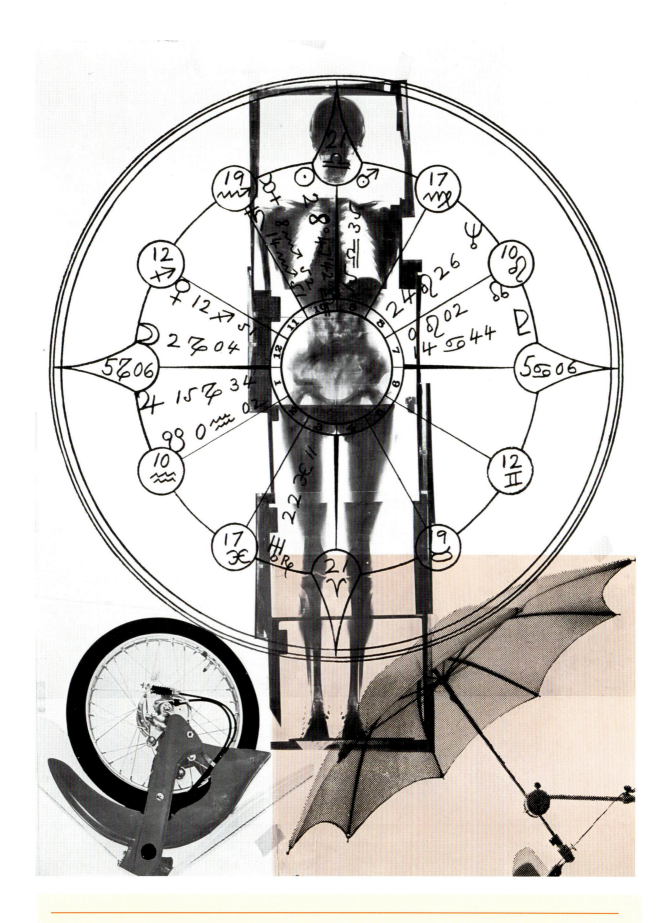

Autobiography, an ambitious review of the artist's life up to 1967, directly refers not only to his personal life, but also to earlier visual works and performances. For example, the first panel includes a reprise of the main image from the 1967 print, *Booster*, in which a full-body X-ray of the artist becomes a multi-stage rocket that he called a "self-portrait of inner-man." The central panel features autobiographical text spiraling around a photograph of the artist as a child on a boat outing with his family. The third panel refers to the artist's first choreographic effort, the 1963 dance performance *Pelican* (Rauschenberg himself is shown roller-skating).

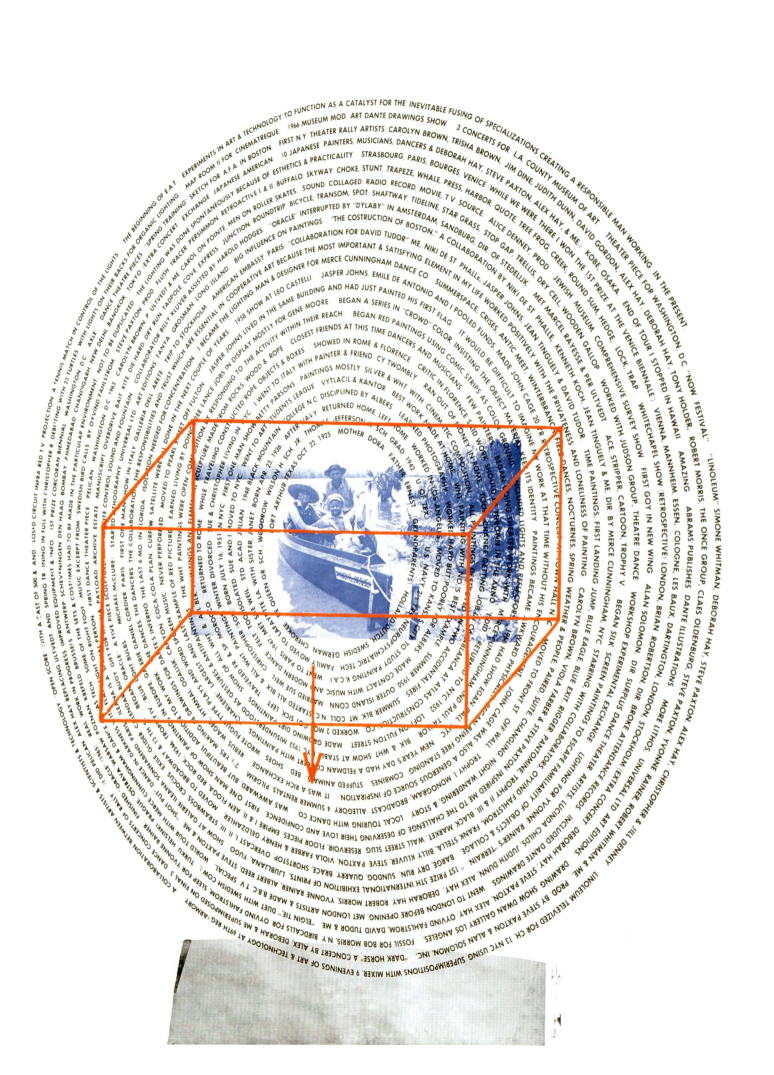

Above and opposite: *Autobiography*, 1968 (sheets 2 and 3). Offset lithograph, 66¼ x 48¾ in. each

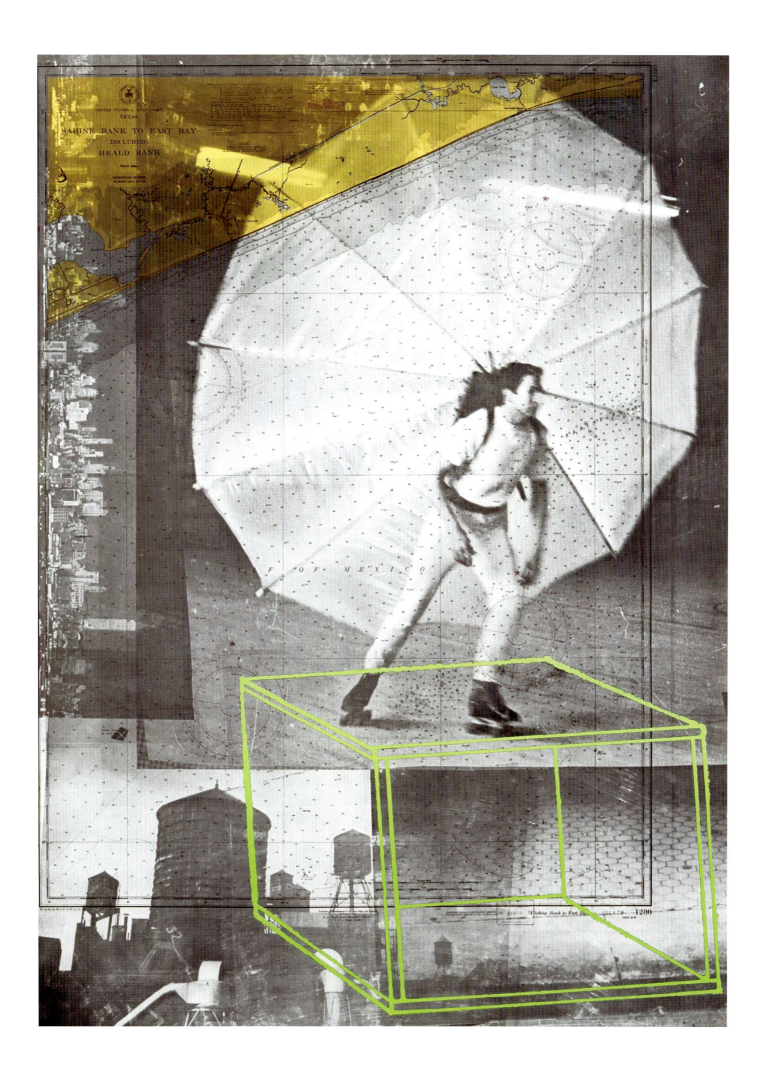

Ruminations

Completed relatively late in the artist's life, the *Ruminations* series documents people and scenes from Rauschenberg's earlier days. As with so many of his works, a combination of family photos, travel souvenirs, signs, and other images work together to evoke a mood and atmosphere of reminiscence, even nostalgia. *Big and Little Bullys* (opposite) includes portraits of his parents, showing them both in early and later stages of their lives (his father's nickname was "Bully"—this is a loving portrait).

Two of the closest relationships the artist had as a young man were with composer John Cage and artist Jasper Johns, or "Jap" (opposite) as Rauschenberg called him. Rauschenberg met both men during the early 1950s at Black Mountain College in North Carolina. He collaborated with Cage on the piece *Automobile Tire Print* (pp. 18, 19), created when Cage drove his Model A Ford (seen twice in *John*, opposite) over an assemblage of blank sheets of paper. In the late '50s, Jasper Johns and Rauschenberg lived in adjacent apartments in New York City where they were able to experiment and exchange ideas. They shared the same art dealer, Leo Castelli, and both were instrumental in pushing the art world out of Abstract Expressionism and into figural representation.

Below: *Big and Little Bullys* (**Ruminations** series), 1999. Photolithograph, 46⅛ x 58⅛ in.
Opposite top: *Jap* (**Ruminations** series), 1999. Photolithograph, 19¾ x 26 in.
Opposite bottom: *John* (**Ruminations** series), 1999. Photolithograph, 29½ x 38¹³⁄₁₆ in.

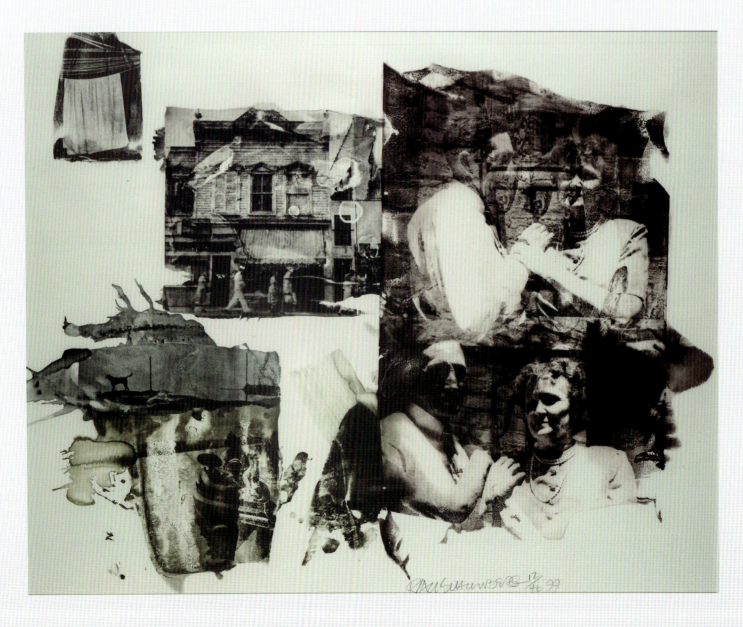

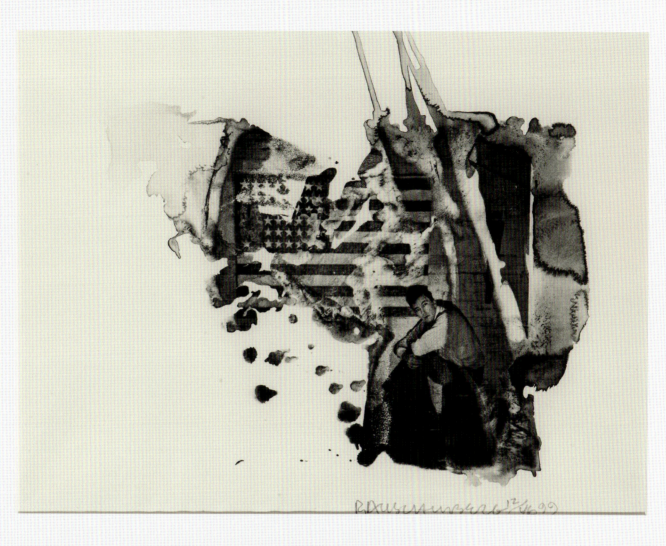

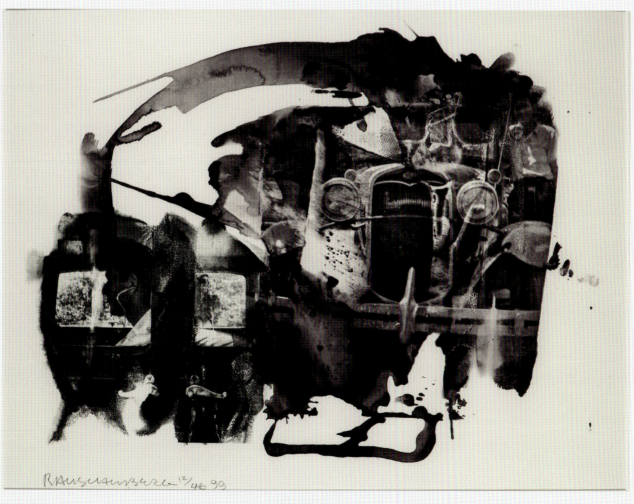

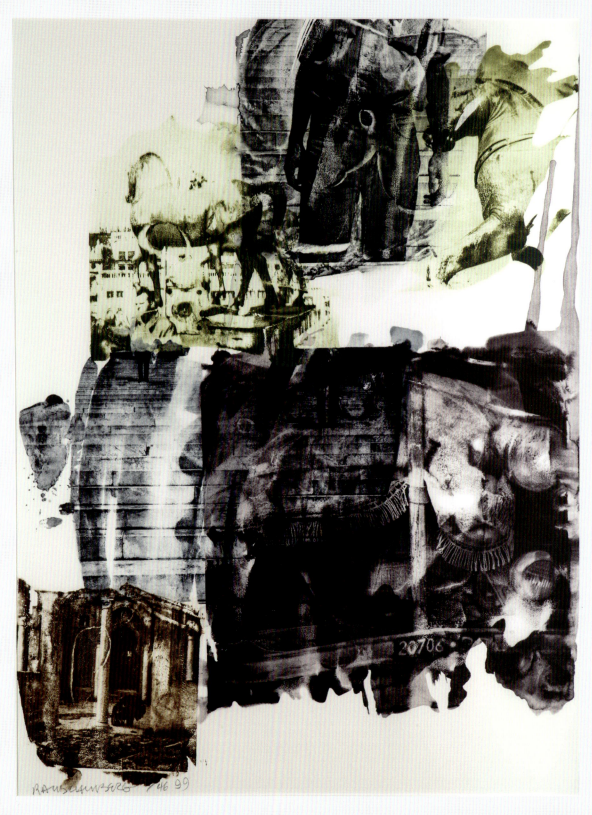

Another of Rauschenberg's many personal and artistic relationships was with abstract artist Cy Twombly. In the mid-1950s, they spent time together, including a long stay in Italy that remained a life-long source of images and inspiration for Rauschenberg, as reflected in *Eagle Eye* (above). In *Ileana* (opposite), he incorporates his own image into a scene with art collector and dealer Ileana Sonnabend, her then-husband Leo Castelli and their son. *Tanya* (opposite) reflects on Rauschenberg's long relationship with

Tatyana Grosman, who founded the fine art print studio, Universal Limited Art Editions (U.L.A.E.) in 1957. He became one of a small group of artists and master printmakers whose technical experiments at U.L.A.E. and elsewhere led to an explosion of creativity starting in the early 1960s.

Above: *Eagle Eye* (**Ruminations** series), 1999. Photolithograph, 49⅝ x 37¹⁵⁄₁₆ in.

Opposite top: *Ileana* (**Ruminations** series), 1999. Intaglio, 26¾ x 31¼ in.

Opposite bottom: *Tanya* (**Ruminations** series), 1999. Photolithograph, 27¹⁵⁄₁₆ x 41⅝ in.

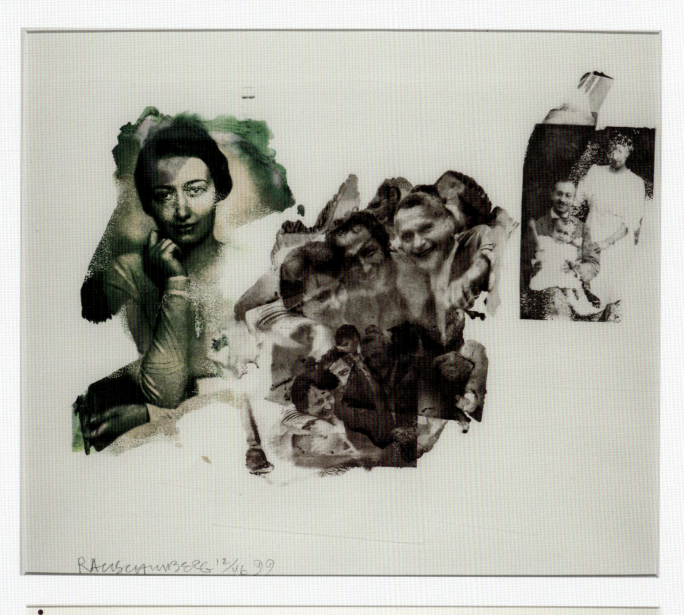

RAUSCHENBERG 12/46 99

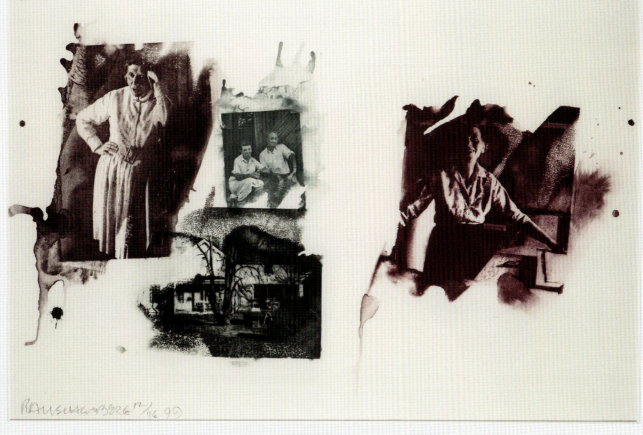

RAUSCHENBERG 12/46 99

Curator's Introduction and Acknowledgements Dan Jacobs

Robert Rauschenberg's artistic and personal tendencies—to bring together, to remember, to include, to share— are inextricably linked. I usually hesitate to declare equivalence between an artist and the artist's *work*—but in Rauschenberg's case, it seems both inevitable and appropriate.

While his life was certainly not free of conflict and adversity (witness his life-threatening struggles with alcohol), there was something profoundly hopeful about him. For example, despite his status as a celebrity artist-activist (he designed the first Earth Day poster in 1970), his advocacy for environmentalism never descended into doomsday messaging. He was able to express anger without despair, and seemed always to be on the lookout for signs of life and hope. This might explain his nearly magical ability to transform the accumulated detritus of our material culture—everything from scrap metal to broken furniture—into artworks.

In his working methods he was above all open—open both to the participation of others, and to the unexpected contributions of random events. In this, he was perfectly attuned to the aesthetics and philosophy of certain close friends in the arts—in this respect most notably the dancer/choreographer Merce Cunningham and composer John Cage, whom he met as a student in the early 1950s. In my interview with master printer Bill Goldston of Universal Limited Art Editions, this exceptionally cheerful openness comes through in several anecdotes.

In the spirit of happy collaboration, I gladly express my own gratitude to a number of people who made the organization of this exhibition and publication such a pleasure. First, of course, I must thank Cynthia Madden Leitner, who approached me with the suggestion that I take on this "reboot" of a project she had long pursued, but which had been on hold for about a year. Her trust in me and in my chosen colleagues is something that I truly appreciate.

I've also enjoyed working with the wonderful staff at the Museum of Outdoor Arts, most particularly Tim Vacca, whose consistent support and input has been invaluable. Tatum Hayes, Sky Madden, Jessica Brack, and

Kelly Jones round out a highly capable team. It has been a great pleasure working with this growing, ambitious and innovative organization.

First among those working with me as consulting associates, I have to mention my co-curator Sarah Magnatta, whose energy, creativity and humor have been essential ingredients in the success of the project. It was a stroke of inspiration for me to ask her for help on this project; she brought practical museum experience and made wide-ranging intellectual contributions to both book and exhibition.

I also owe a debt of gratitude to my long-term collaborators Rupert Jenkins and Mary Junda. Rupert provided expert, efficient and sensitive editorial services for this book and for exhibition interpretive materials, while Mary delivered publication and exhibition graphics with her usual flair. Pamela Marquez performed additional editorial services, and William O'Connor provided expert photography. I received research and other support from my assistant Kate Woestemeyer.

The lenders are named in the Director's Foreword, so I will simply add my thanks here without repeating the list. What a pleasure it's been to experience their generosity in sharing such an impressive group of works! We've uncovered some very special artworks right here in Colorado, including one of the rare, important and previously unpublished versions of *Accident*, a globally influential print of 1963 lent by Lily Appelman and Eugene Heller, whom I single out for special thanks.

Contributing authors to this publication include three expert scholars: Dr. Hiroko Ikegami, who provides overviews and a theoretical framework for examining the ROCI experience in three Asian countries (China, 1985; Japan, 1986; Malaysia 1990); Dr. Sarah Magnatta, who complemented Hiroko's work by reaching out to

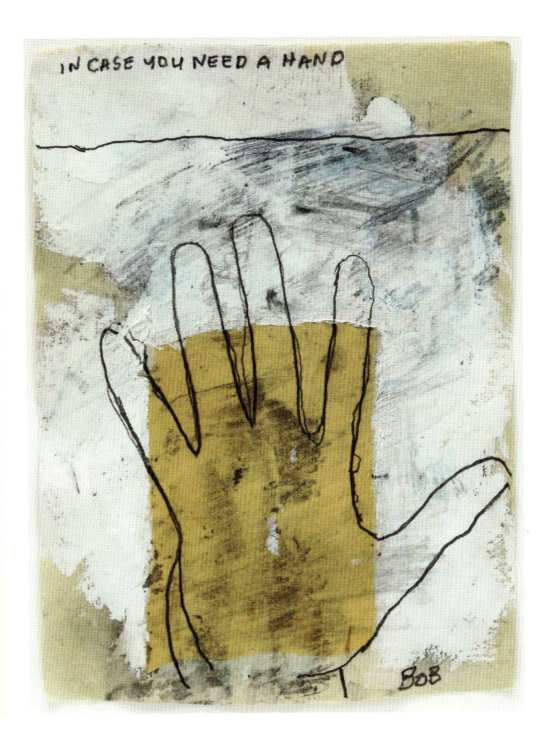

IN CASE YOU NEED A HAND

BoB

The Hand of the Artist

While his works often show a strong interest in politics, society, the environment and other "external" matters, Rauschenberg often directly referred to his more intimate, internal experience. *In Case You Need a Hand* shows the hand of the artist as an actual tracing; the universal hand gesture signifies, "I was here." Rauschenberg's large-scale *Autobiography* (illustrated in the preceding pages), and other works throughout the exhibition contain hundreds of photos and references to his family, friends, career, pets, and other aspects of his personal life.

In Case You Need a Hand, 1995. Solvent transfer, acrylic and collage on paper, 11 x 8¼ in.

several Tibetan artists to gather recollections of their exposure to Rauschenberg in Tibet (1985); and Dr. Sienna Brown, who builds on her research into Rauschenberg's affinity for printmaking in a way that affirms the artist's particular interests and abilities. My interview with Bill Goldston was enormously helpful to me in understanding how profoundly Rauschenberg's personality permeated his whole approach to making art. I would like to thank him, and each of our authors, for their contributions to this book.

Finally, I would like to mention the help we received from colleagues around the country and beyond who contributed logistical support, connections and ideas to the evolving project. There are several I can't name, as it

would render anonymous lenders less anonymous—but I hope that they'll accept my thanks just the same! Those that I gratefully acknowledge here include: Bill Goldston, Marie Tennyson and Jill Czarnowski at Universal Limited Art Editions; Maggie Mazzullo at the CU Art Museum, Boulder; Jade Dellinger at the Bob Rauschenberg Gallery, Florida SouthWestern State College; Florida sculptor and Rauschenberg collaborator Lawrence Voytek; master printer Gregory Santos; photographer Roddy MacInnes; Ayumi Watanabe at MoMA Shiga, Japan; Melissa English at the Powers Art Center, Carbondale; Nicole Parks and Geoffrey Shamos at the University of Denver, which holds the Madden Collection; and John W. Madden, Jr., the donor of that exceptional collection.

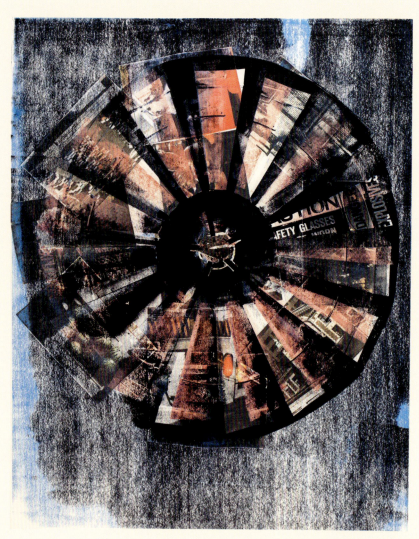

The Passage of Time

Windmills appear prominently in Rauschenberg's work, perhaps reflecting the artist's attraction to the dynamism of the spinning blades. His interest in representing time itself is explicit in *Sterling/Whirl*, 1993 (opposite), which includes a clock face echoing the shape of the windmill blades. Tires, wheels, clocks, and bicycles appear often in Rauschenberg's work. Collectively, they can be viewed as reflections of his fascination with machinery, his sense of travel and motion, and the overarching interest in the passage of time.

Windward Series VIII, 1992. Acrylic, solvent transfer, and graphite on paper, 60 x 37¾ in.

Opposite: *Sterling/Whirl*, 1993. Acrylic screenprint on Lexan and paper, 40 x 59¾ in.

Below: *Lithograph I* (*Glacial Decoy* series), 1979. Lithograph, 32 x 48 in.

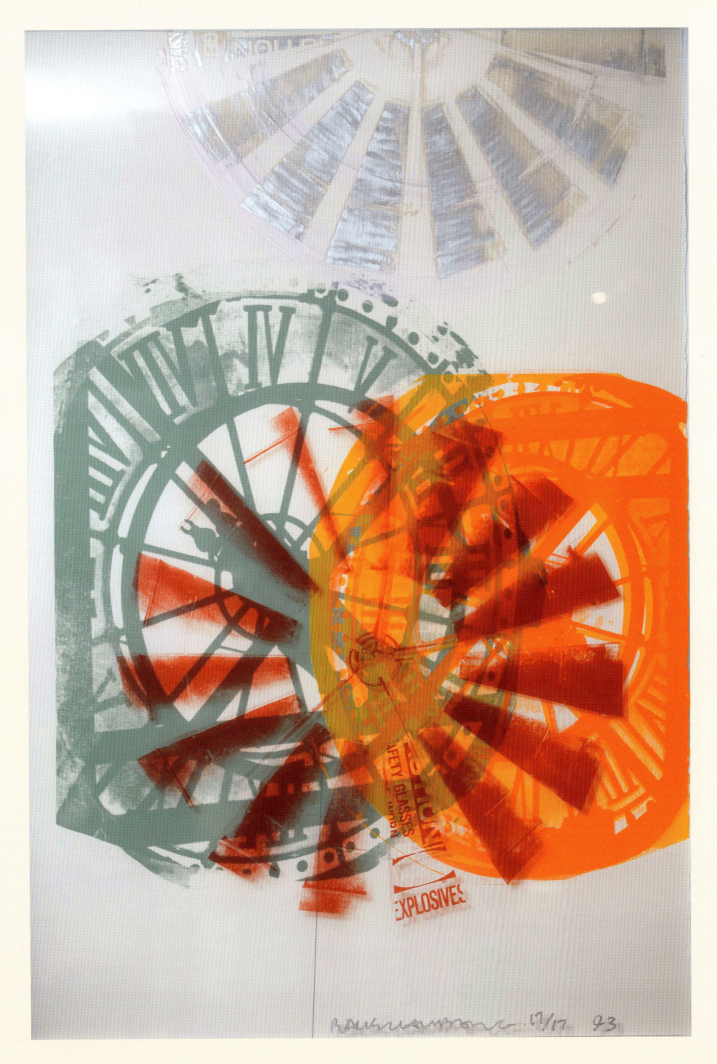

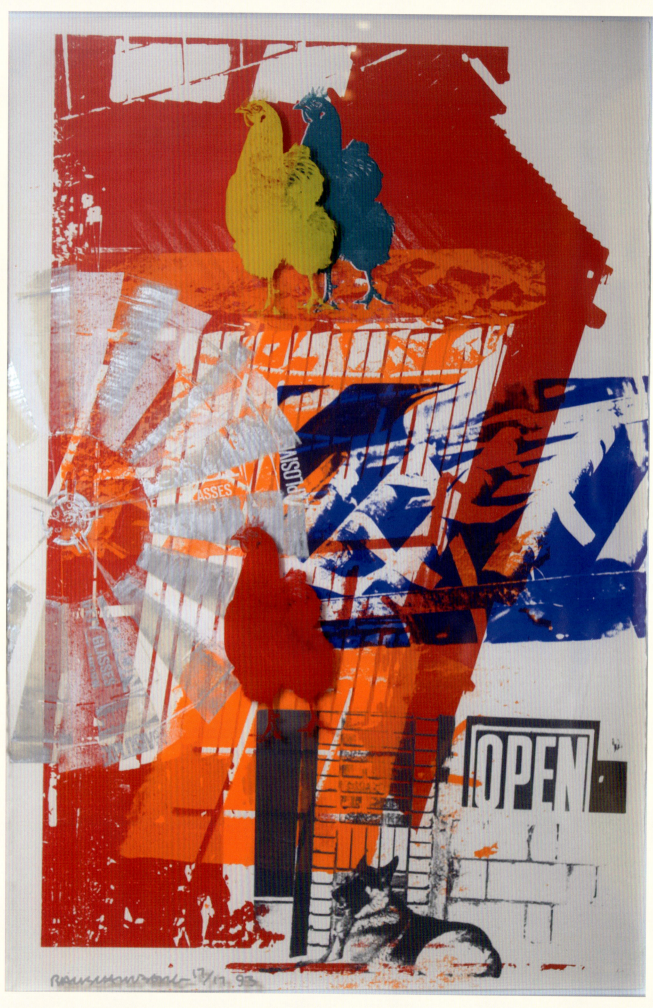

Cock-Sure, 1993. Screenprint, firewax, pigment on paper and Lexan, 59¾ x 40⅛ in.

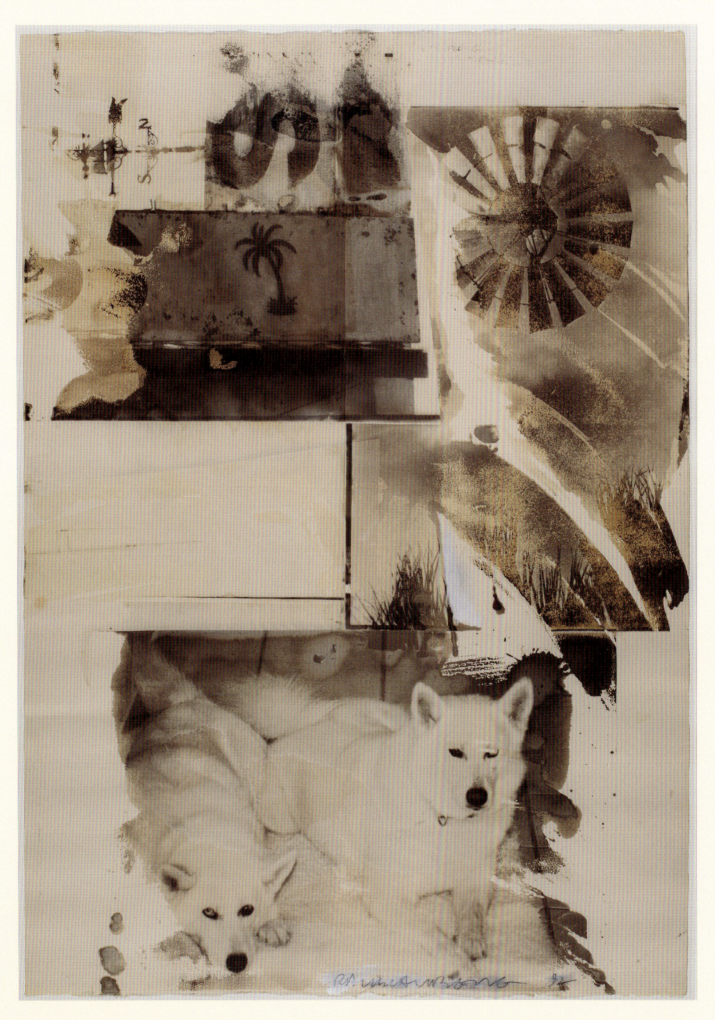

***Bedlam* (*Waterworks* series)**, 1992. Vegetable dye transfer on paper, 4¾ x 29½ in.

Robert Rauschenberg and the Logic of Printmaking

Sienna Brown, PhD

Referring to lithography, Robert Rauschenberg once said, "the twentieth century is no time to be drawing on rocks."[1] Despite his initial misgivings about the technique, Rauschenberg became one of the foremost lithographers of his time. Starting in 1962, he quickly mastered the technique and pushed the boundaries of lithography and other printing methods.

His apparent ease with an unfamiliar medium can be attributed to the working processes he developed during the 1950s and carried through the next five decades. I argue that all of Rauschenberg's works, both printed and otherwise, display three critical and visual concepts that are tied to the mechanics and methods of printmaking: the index, the flatbed, and repetition. Together, these three concepts form what I call his personal "logic of printmaking." I'll refer to three works in some detail: the monotype *Automobile Tire Print* (1953), the lithograph *Accident* (1963), and *Ileana* (from the *Ruminations* series, 1999). These works, spread over the artist's career, demonstrate the sustained importance of printmaking, along with his exploration and expansion of the medium.

The Index

As defined by the philosopher of language Charles Sanders Peirce in the 1860s, "an Index is a sign which refers to the Object that it denotes by virtue of being really affected by that Object."[2] According to this definition, an image or object is considered an index when it is created by a direct physical relationship with the object it represents; it's created through an act. A classic example of an indexical mark is a footprint in the sand. When we see a footprint, we know it was made when someone walked on the sand; it is the record of that action.

In 1953, the composer John Cage and Rauschenberg collaborated on the last print Rauschenberg made before turning to lithography in 1962: *Automobile Tire Print*. Rauschenberg glued twenty hand-trimmed, blank pieces of paper together to create a strip approximately twenty-two feet long. On a quiet and rainy Sunday, Rauschenberg laid the long piece of paper on the street in front of his Fulton Street studio.[3] Twice, Cage slowly drove one side of his Ford Model A over the paper while Rauschenberg applied black paint to the rear tire.[4] The mark of the tire on the paper is a record of the twenty-two-foot drive taken by Cage. The tread varies in both width and clarity as it weaves over the paper. A faint second tire track can be seen on the paper under the painted one; this second track is a transfer of dirt from the front, unpainted, tire. This work points to Rauschenberg's engagement with indexical mark-making.

Another important print shows how Rauschenberg continued his exploration of indexicality. In 1962, he'd begun to make lithographs at the print shop Universal Limited Art Editions (U.L.A.E.) in West Islip, New York, and the following year, he produced the aptly named *Accident* (p. 20). After just one print was produced during the proofing process, the large lithography stone snapped as the next proof was being printed. Instead of discarding the design and broken stone, as was customary when such an event occurred, Rauschenberg made the bold decision to print an edition from the broken limestone. The debris from the crack became elements in the composition.

Rauschenberg dipped the chunks of broken limestone in "tusche," a type of oily ink used in lithography, and impressed them on an intact second stone. He then added crayon marks by hand to indicate the pile of shards of rock at the bottom of the composition. As the edition was printed, the two halves of the broken stone shifted, so every print from this edition is slightly different.

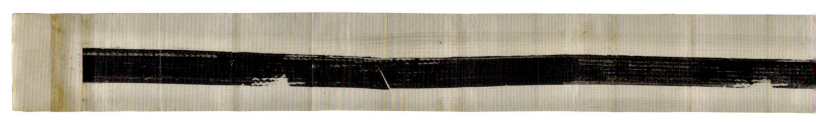

Drawing on Stone

Lithography became a very important part of Rauschenberg's artistic imagination. In early prints like *Abby's Bird* (right) and *Accident* (next page), he explored the more traditional aspects of the form, which involve drawing on a fine-grained stone with oily materials (including a special type of grease pencil); the resulting images attract oil-based inks which can then be transferred to paper under mild pressure. As with most traditional printing methods, each color is inked and printed separately, with time for the ink and paper to dry out between each impression.

Invented in 1796, lithography relies on the mutual repulsion of oil and water, and in its early days was the only method that allowed for affordable, high-quantity reproduction of images drawn directly on the printing surface. Later, similar techniques were expanded to include printing "lithographically" from metal plates and sheets, and using images created from photographs. These photo-based techniques were the mainstay of commercial printing throughout most of the 20th century. Rauschenberg embraced and even helped to develop many innovative lithographic methods, applying them to his fine art.

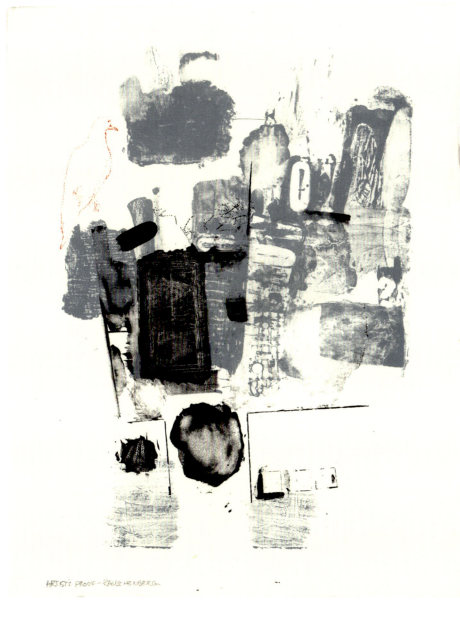

Abby's Bird, 1962. Color lithograph from three stones on white wove paper, 19¾ x 13¹³⁄₁₆ in.

Printmaking is an inherently indexical medium. To make a print you press a matrix onto a support, in this case a limestone block and paper. That act makes the art object. In this print the indexicality is amplified by Rauschenberg's interaction with the stone. Fingerprints on the left side of the composition are evidence of the artist's physical contact with the lithography stone. He dipped three fingers into tusche and dragged them across the printing surface. Early proofs show that these finger marks were part of the original design, and among the first images applied. After the stone broke, the irregularity of the limestone along the diagonal fissure captured more ink then the rest of the stone, creating visible pooling along the line. Thus even where the image to either side of the break is light, there is a dark line that traces the fissure and is an index of the edge of the stone, something that is usually unseen in lithography (in order to avoid breaking the finely textured limestone slab, pressure is rarely applied all the way to the edge). Because the break in *Accident* runs through the middle of the composition, the thousands of pounds of pressure exerted by the press on the stone is also recorded as light embossing visible along the crevice.

Automobile Tire Print, 1953. Paint on 20 sheets of paper mounted on fabric, 16½ x 286 in. San Francisco Museum of Modern Art; Purchase through a gift of Phyllis C. Wattis © Robert Rauschenberg Foundation. Photograph by Don Ross

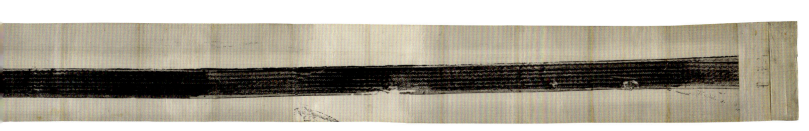

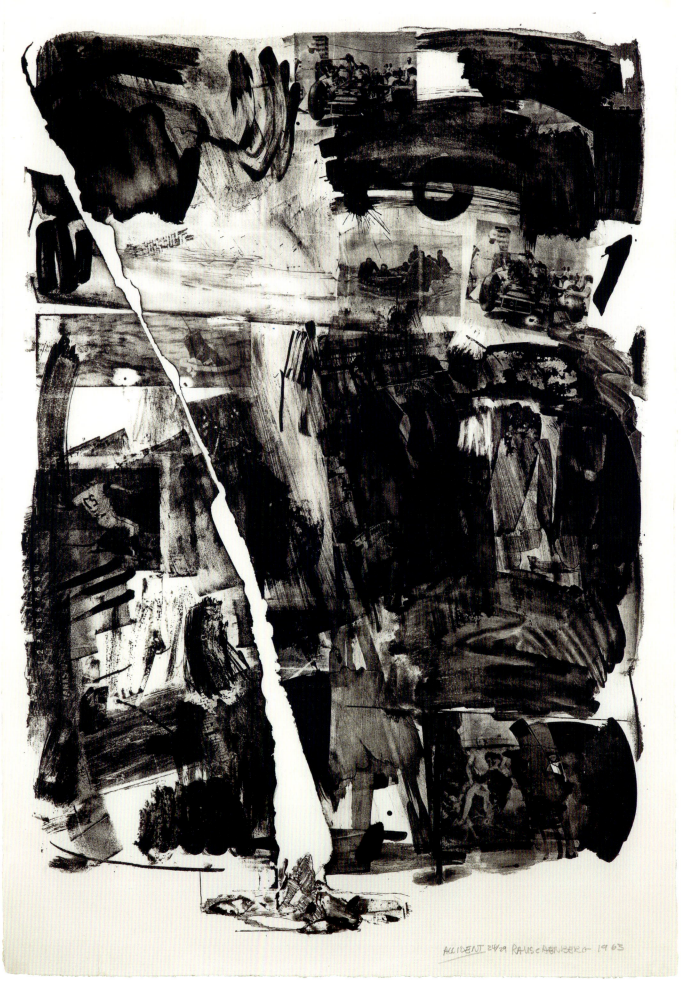

Accident, 1963. Lithograph, 41⁵⁄₁₆ x 29½ in.

The Flatbed

In 1954, Rauschenberg began the groundbreaking works he dubbed "Combines." These works inspired art historian Leo Steinberg's theorization of what he calls the *flatbed picture plane*. The flatbed picture plane, according to Steinberg in his essay "Reflections on the State of Criticism," is one that is horizontal in its conception as opposed to vertical like an easel painting. This change in orientation begins with Rauschenberg's Combines. "These pictures no longer simulate vertical fields but opaque flatbed horizontals," Steinberg writes.[5] In order to develop the idea of the flatbed picture plane, Steinberg drew heavily upon the technology and ideas of printmaking, saying, "I borrow the term from the flatbed printing press."[6] When Steinberg describes this new orientation he explains that it is any surface onto which something can be printed or impressed.[7] In other words, the medium of printmaking is at the core of Steinberg's concept of the flatbed. Unlike canvas or paper, printing stones and plates can only be worked on while they are flat. The weight of the lithography stones, the acid bath of etchings, and the carving of woodblocks does not allow for any orientation of production other than a horizontal one. Steinberg's work reveals that Rauschenberg's logic of printmaking is at play even in his Combines, which are usually described as paintings. In fact, these pieces demonstrate the importance of this logic in all of Rauschenberg's work, both printed and otherwise.

Although the Combines inspired Steinberg's concept, he could have just as easily referred to the *Automobile Tire Print*. The horizontality of the work is clear. A car track is a familiar mark that one sees on the ground, so when viewing the work on the wall the viewer is conscious of the horizontal orientation of its making. Furthermore, as a print, *Automobile Tire Print* reinforces the essential relationship between the printmaking medium and Steinberg's flatbed notion.

Accident, in spite of being made on an actual printer's flatbed, would seem to work against Steinberg's proposition. The work shows the stone breaking and fragments of limestone falling to the bottom, as if the stone was placed vertically and gravity pulled the bits and pieces down. However, elements within the print reveal the artificiality of the apparent vertical orientation and the persistence of the horizontal—the flatbed—in the work's execution. First, the physicality of the stone is emphasized in the print itself. The rough edges of the rock remind the viewer of the material used to make a lithograph: a large piece of limestone weighing over one-hundred pounds. The impression of the rough edges into the dampened paper created during the printing process is also a clear evocation of the actual flatbed press used to make the print. Close examination of the stone fragments at the bottom of the print exposes its constructed nature. The debris is largely made up of printed limestone pieces. However, the artist created some of these fragments by outlining a stone shard with crayon and then filling in the ragged shape with his distinctive scribble. The chunks of stone at the bottom appear to be piled on top of a line, also drawn by the artist. The stark artificiality of the debris pile underscores the actual horizontality used in the work's fabrication. Thus, even when the print seems to work against horizontality the object is tied to the flatbed conceit by the confines of the lithographic medium itself. Rauschenberg exploits this tension between horizontality and verticality to powerful effect.

Repetition

Like the flatbed and the index, repetition is intrinsic to printmaking as the product of this activity is not one object, but rather an edition of objects, a set of originals. Rauschenberg goes beyond a basic use of repetition, and the thinking of Gilles Deleuze helps illuminate the artist's technique. Deleuze published *Difference and Repetition* in 1968. Somewhat paradoxically, for Deleuze, difference in itself is revealed through repetition: "Difference inhabits repetition."[8] Because of this, repetition is not equivalence or substitutability; there is repetition because there is difference within the elements that are repeated. The idea of difference and repetition being paired terms is well-illustrated in Rauschenberg's prints.

Automobile Tire Print appears at first to be one continuous mark—an index of the passage of the car, as we've seen. However, close examination reveals that the painted tire track passed over the paper twice, indicating that the drive was repeated. Even without close examination, the repeated forms of the chevron-patterned tire tread are clear, as are the variations created through uneven wear on the tires and by the irregular surface of the street. It is through differences in the repeated *V* shapes that the two distinct drives are revealed, underscoring Deleuze's "difference that inhabits repetition."

A similar interaction between repetition and difference can be seen in *Accident*. Repetition occurs within each print: in the upper right corner, the picture of a racing car appears twice. At lower left, repeating imagery used in other works from the 1960s (e.g. *Stunt Man III* of 1962), Rauschenberg placed a picture of a baseball player. As the edition of *Accident* was printed, the two halves of the broken stone shifted, so each print from the edition is slightly different. This planned aberration counters the tradition of lithography, which prizes consistency within an edition, but reflects the Deleuzian idea of repetition in which difference is key. The individual prints are not identical but are repetitions of the printing of the broken matrix.

As the millennium drew to a close, Rauschenberg embarked on a series of highly personal works: *Ruminations* (1999–2000). Printed at U.L.A.E., this body of work consists of nine prints in a combination of intaglio, photogravure, and (in one case) lithography. With these prints, he pays homage to the people in his life who influenced him and his art: his parents Ernest and Dora, sister Janet, son Christopher, collector Ileana Sonnabend, publisher Tatyana Grosman, dancer Steve Paxton, composer John Cage, and fellow artists Jasper Johns and Cy Twombly. Although Rauschenberg always threw himself fully into his work, rarely is the product as biographical and personal as these prints.

Ileana (*Ruminations*) is the only print from the series to use lithography, and the only one not of a family member to feature a self-portrait of the artist (p. 11). Ileana Sonnabend was an early supporter and collector of Rauschenberg's work as well as a lifelong friend. In this print, a glamorous portrait of a young Ileana and a photograph of her with her husband Leo Castelli and their son flank overlapping pictures of Rauschenberg with his arms wrapped around the pair. Repetition is perhaps the most obvious element of this work, with doubled images at the center and multiple pictures of *Ileana*. Each portrait is different, though, as they represent individual moments in the collector's life, and are printed with varied clarity. The differences within the images act to underscore the extended friendship of Ileana and Rauschenberg.

————————

In order to create the photographically based images, the pictures were transferred to photosensitized metal plates. Rauschenberg then smeared developer on the plates in wide, painterly brush strokes. Only where the developer had been applied would the photo-transferred images be susceptible to the acid bath of etching. This fusion of photographic image and autographic brushwork undermines the potential illusionistic depth of the photographs, emphasizing the flatness of the printed medium and its reliance on horizontality for production. Using his own distinctive brush stroke, Rauschenberg reveals his physical involvement in the object's production as the hand of the artist is heavily implied in the marks throughout the print. Like a footprint in the sand, these swaths are an index, a mark made by a physical interaction. These threads of the logic of printmaking are present even here, creating a line from Rauschenberg's earliest works through to those made nearly fifty years later. *Accident, Automobile Tire Print*, and *Ileana* (*Ruminations*) are just three pieces that illustrate his personal and highly inventive logic. In works such as these, the principles of the index, the flatbed, and repetition intertwine and establish this logic as an effective method for considering Rauschenberg's artistic production and his enduring relevance.

————————

Painting on the Flatbed: The *Ground Rules* series

In the preceding essay, Sienna Brown applies the term *flatbed picture plane* to Rauschenberg's work, starting with his development of *Combines* in the 1950s. In an interview for this publication, U.L.A.E. master printer Bill Goldston describes a "flatbed" process: a new technique he developed with Rauschenberg for "painting" prints directly onto plastic-backed watercolor paper for the *Ground Rules* series in 1996–97. The team figured out how the artist could could paint with photographic developer directly on a photosensitive sheet of plastic. For *Ground Rules* prints, Goldston prepared sheets of Lexan with a photographic emulsion. After immersion in fixing liquid, the Lexan-backed image became light-stable, and could be used as the basis for further printing steps. He describes the scene in the darkroom, making clear how much of the work took place horizontally:

> We developed the "Ground Rules" series that way. … He had a very good enlarger, but we had to run the enlarger all the way to the ceiling. We had this little piece of film up there at nine feet, and were projecting it down onto the floor. We had our timing set to expose the film for two minutes, and then I'd put it in a dry tray. … And we had these little blocks that we put it on, so that anything on it would run off and get out of the way. I had these three containers mixed up with developer, different strengths, set up in front of Bob. I'd hold one and give it to him if he needed it. He'd throw the brushes in developer, and then he splashed developer on the exposed image. So, we just produced this beautiful image across the bottom of this print. If you look at "Back-up" you can see it. There's this beautiful image across the bottom.

Endnotes

[1] Mary Lynn Kotz, *Rauschenberg: Art and Life* (New York: Harry N. Abrams, Inc., 1990), 143.

[2] Charles Sanders Peirce, *Philosophical Writings of Peirce*, ed. Justus Buchler (New York: Dover Publications, 1955), 102.

[3] Walter Hopps, *Robert Rauschenberg: The Early 1950s* (Houston: Menil Foundation, Inc., 1991), 160, and documentation at the San Francisco Museum of Modern Art. It is unclear from the documentation if the car was driven forwards or backwards. Close examination reveals that there were points where the car direction was switched and there are two overlapping painted tracks on the paper.

[4] Hopps, 160.

[5] Leo Steinberg, "Reflections on the State of Criticism," in *Robert Rauschenberg*, ed. Branden Joseph (Cambridge: MIT Press, 2002), 28.

[6] Steinberg, 27.

[7] Steinberg, 28.

[8] Gilles Deleuze, *Difference and Repetition*, trans. by Paul Patton (New York: Columbia University Press, 1994), 76.

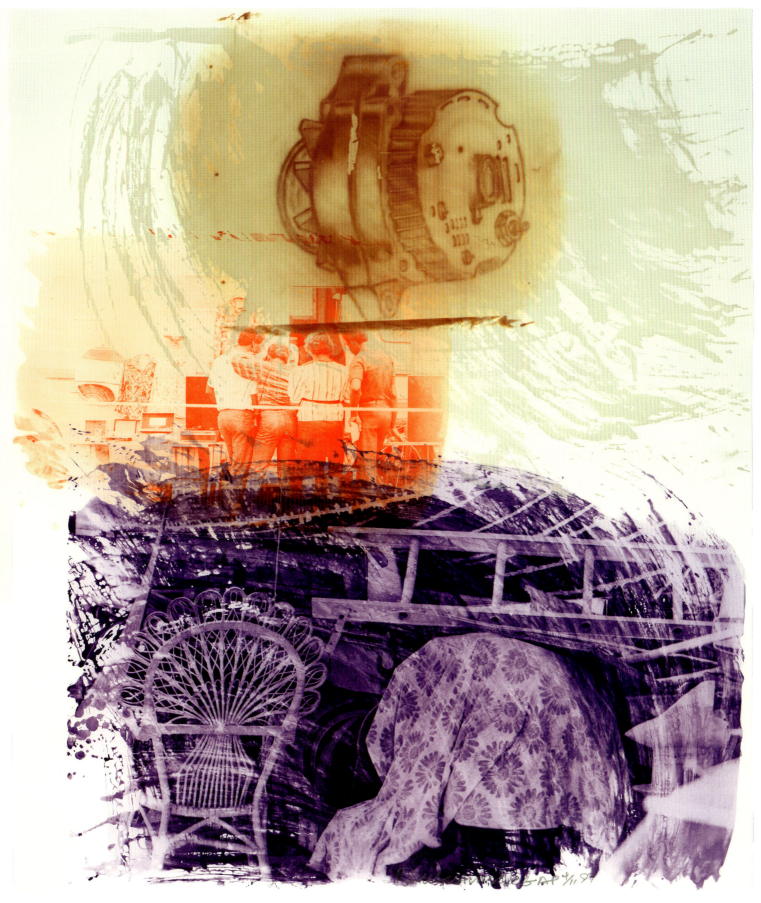

Back-up (***Ground Rules*** **series)**, 1997. Intaglio in 5 colors with photogravure, 57½ x 49⅝ in.

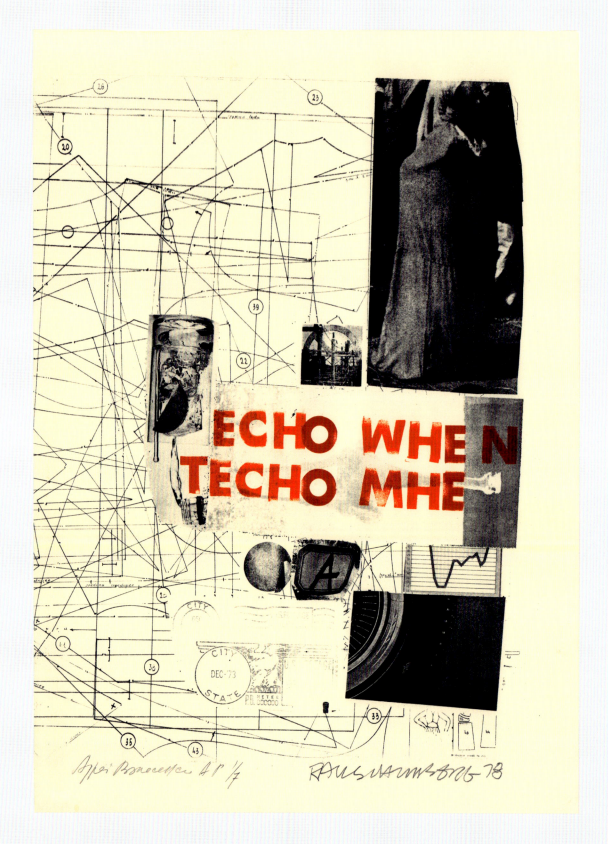

Early Cultural Exchanges

Echo When and *Darkness Mother* are two of six prints Rauschenberg created in collaboration with Russian poet Andrei Voznesensky in 1978. Working with three stones for each of these lithographs, the artists combined text with image in an aesthetic conversation that echoes the collaborative effort of the artists. This project shows Rauschenberg's growing interest in international collaborations in the years just prior to the ROCI (Rauschenberg Overseas Cultural Interchange) program.

Above: *Echo When*, 1978. Color photolithograph and lithograph from three stones on cream wove paper, 28 x 20 in.

Opposite: *Darkness Mother*, 1978. Color photolithograph and lithograph from three stones on cream wove paper, 28 x 20 in.

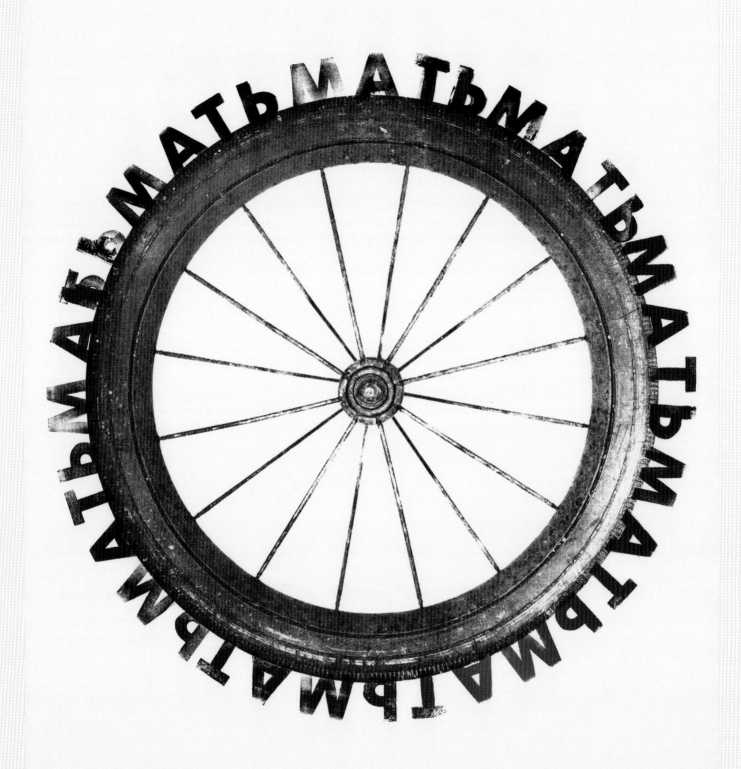

Русское Возрождение A P ¹/₇ RAUSHENBERG 78

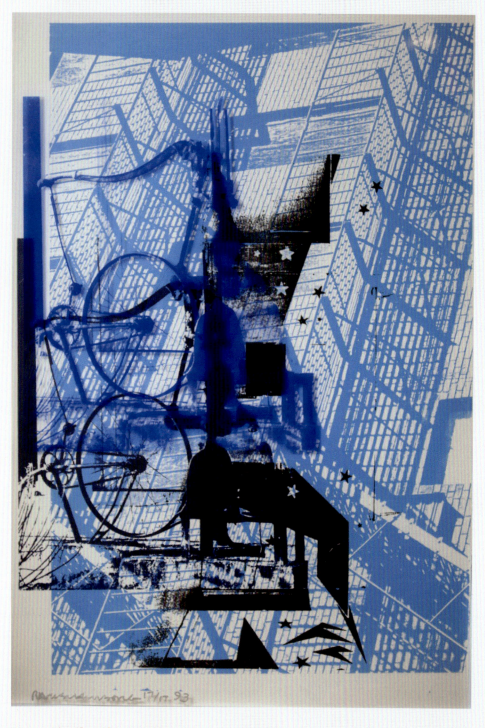

Prime Pump (ROCI USA/Wax Fire Works series), 1993. Screenprint on paper and Lexan, 40 x 59¾ in.

Opposite: *Soviet/American Array VII*, 1988–1991. Photogravure, 78⅝ x 51 in.

More Similar than Different

In many of the prints created for the USSR leg of the ROCI (Rauschenberg Overseas Cultural Interchange) tour in 1989, the artist combined images from the United States and Russia, documenting everyday scenes from the two major Cold War powers just as that period was coming to an end.

In *Soviet American Array VII*, the artist used an image of a high-rise Soviet structure (the tallest university building in the world) next to a series of New York City apartments, which appear almost as a continuation of the Russian building. As the title suggests, the print is an array of images—the photographs of U.S. structures blend seamlessly with those of the Russian buildings.

With *Prime Pump*, created a few years later, Rauschenberg continued to employ the perspective of a cultural tourist to his home country, using images of industry and street life that highlight both the strangeness and beauty of the visual environment. This work and others from the *ROCI USA* series make clear his intention that this continuing "travelogue" should help to expand our horizons.

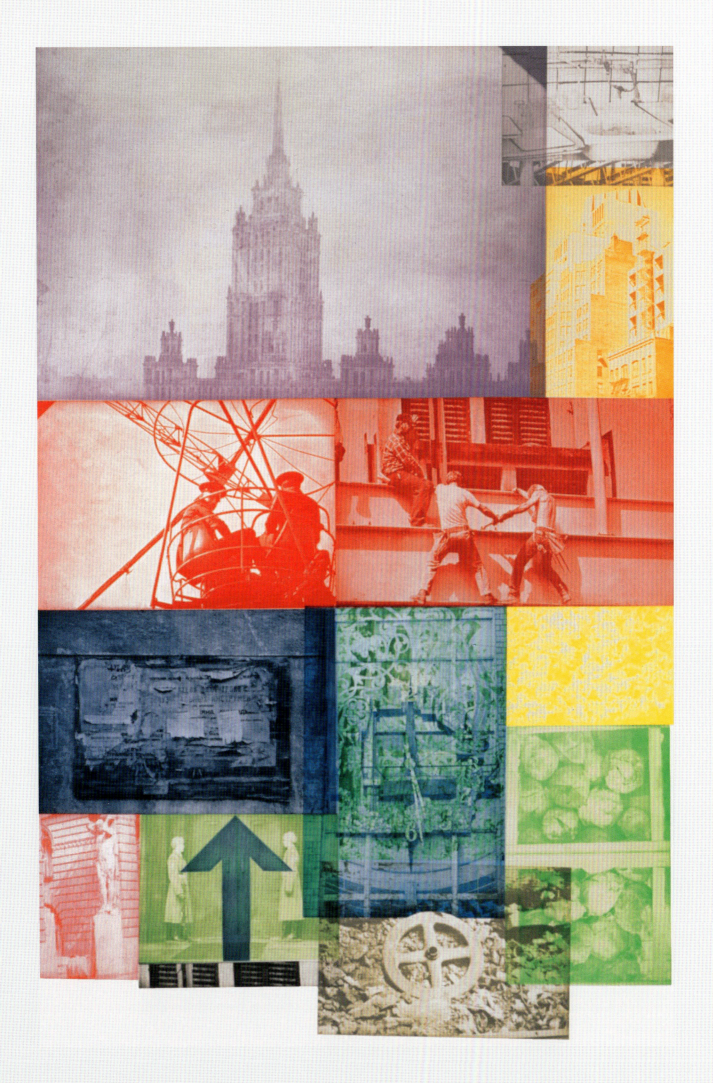

A Historical Reflection on Rauschenberg in Asia

Hiroko Ikegami, PhD

For Robert Rauschenberg, the 1980s was a decade of ROCI—the Rauschenberg Overseas Culture Interchange (1984–91). Pronounced "Rocky" after his pet turtle, ROCI was an international traveling exhibition intended as a cultural exchange program. The project was gigantic in scale and unprecedented with its focus on what Rauschenberg called "sensitive areas"—countries that had little contact with American culture or modern art because of their undemocratic political systems. Announced at the United Nations in 1984, the project toured to ten countries between 1985 and 1990—Mexico, Chile, Venezuela, China, Tibet, Japan, Cuba, the Soviet Union, East Germany, and Malaysia, in the order of the itinerary—before it concluded at the National Art Gallery in Washington DC in 1991. A project of this magnitude had never been undertaken by an individual artist before, and it had a significant impact on the globalizing art scene of the late 80s.

ROCI originated in Asia, when Rauschenberg visited China for the first time in 1982. Shocked by the lack of freedom and the state of inertia in the country, he conceived of the project as a peace mission to introduce the world, through his art, to people of various countries with restricted freedom of expression. As a result, the ROCI tour included no less than four venues in Asia. However, as conditions within these countries were fundamentally different—with China under the Communist regime, Japan being a close ally of the United States, and Malaysia as a developing nation under authoritarian rule—ROCI meant different things in different locales. Perceptions of ROCI also varied from one individual to another on both sides of Rauschenberg's team and hosting countries. Based on a series of interviews I conducted with involved parties, this essay therefore attempts to convey a historical reflection on ROCI to consider Rauschenberg's legacy in three Asian countries: Japan, China and Malaysia. Meanwhile, elsewhere in this volume, Sarah Magnatta adds some preliminary research on ROCI's reception in Tibet.

ROCI's Formation in Asia

Rauschenberg's 1982 trip to China mainly had two objectives. One was to work at the Xuan paper mill in Jingxian, Anhui Province, said to be the oldest paper mill in the world, where he produced the paper-based collage series *7 Characters* (right) in collaboration with the mill's craftsmen.[1] The other was to collect images for the project known as *Chinese Summerhall*, a one-hundred-foot-long installation of collaged images printed on a single sheet

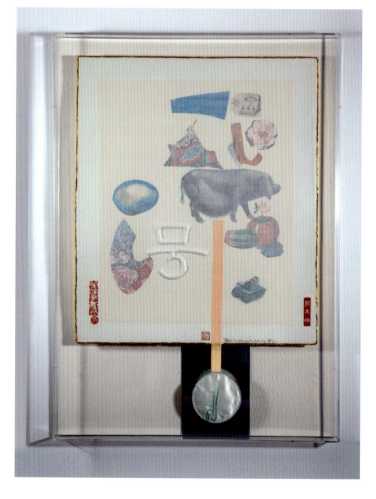

Howl (*7 Characters* series), 1982. Silk, ribbon, paper, paper-pulp relief, ink and gold leaf on Xuan paper, with mirror, framed in a Plexiglas box. 43 x 31 x 2½ in.

28

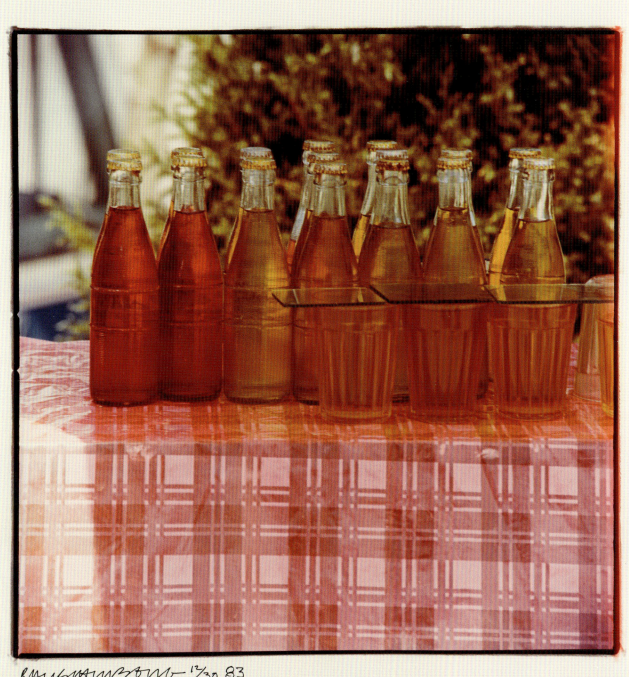

RAUSCHENBERG 12/30 83

Study for Chinese Summerhall (Bottles), 1983. Chromogenic print, 40 x 30 in. Portfolio of 10 prints published by Graphicstudio, University of South Florida, Tampa, FL.
Photograph by Will Lytch

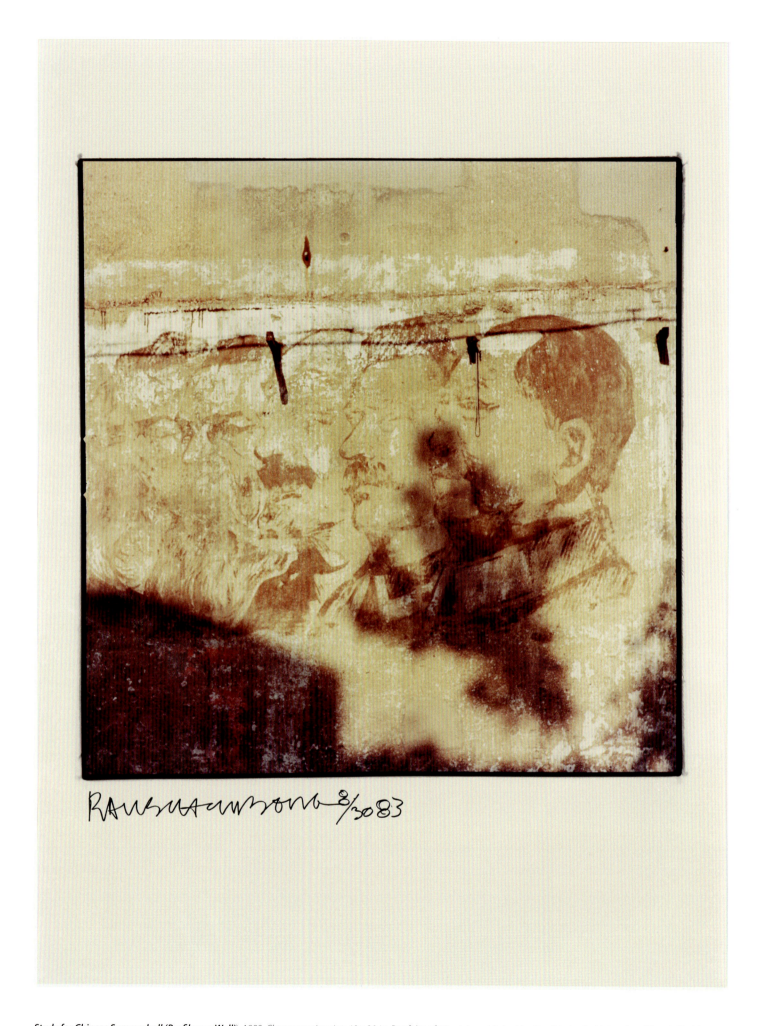

Study for Chinese Summerhall (Profiles on Wall)), 1983. Chromogenic print, 40 x 30 in. Portfolio of 10 prints published by Graphicstudio, University of South Florida, Tampa, FL. Photograph by Will Lytch

of photographic paper.[2] For this purpose, Rauschenberg traveled through the country for three weeks before going to Jingxian, and shot over fifty rolls of film with his Hasselblad camera. These photographs show various aspects of Chinese life at a time of drastic social and economic reform following the Cultural Revolution, which had lasted from 1966 to 1976. Rauschenberg's camera eye was objective, though. While one of his images shows a wall bearing faded profiles of socialist leaders, including Chairman Mao and Stalin, others capture casual street scenes such as laundry hanging before an apartment and bottled drinks (not Coca-Cola, yet) on the table (opposite and p. 29). Shot candidly in a style reminiscent of Walker Evans, his photographs capture the striking beauty of everyday life in China at a pivotal historical moment.

If Chinese traditional craftsmanship and contemporary landscape had a profound impact on Rauschenberg's artistic production, the restrictions and the resulting lack of curiosity in China troubled him deeply. During his trip, he saw a blindfolded water buffalo tethered in a brickyard and walking around in circles to power a machine. As he recollected, the sight became a metaphor for what such constraints could do to living beings: "Once you kill the curiosity, everything else goes."[3] This condition seems to have affected all aspects of Chinese life. In Jingxian, he met a Chinese cook who hadn't seen his family for years because he needed permission to travel twenty miles away. In Beijing, he saw art students unquestioningly following professors' instructions to paint in the same insipid style, but actually thirsting for information from the outside world. Reflecting on his visit to this art school, Rauschenberg stated:

That was one of the most embarrassing moments of my life. These anxious young people were waiting for me to say something about their work. The reason the work looked like it did was because that was the only thing they were allowed to do. So you couldn't praise them but, on the other hand, you couldn't deny them or put them down. [4]

These experiences convinced Rauschenberg of the need for a cultural exchange program through which people of countries with varying degrees of repression could see and know about other cultures as well as their own. Crystallized as ROCI, its basic procedure can be summarized as follows: Rauschenberg and his team would travel to a chosen country to immerse themselves in local life and culture, and to gather images and materials. They would then create new works in Captiva, at the artist's property off the coast of Florida, and return to the country to mount a ROCI exhibition that included works made previously in other countries.

Donating a work to a hosting institution, then, the ROCI tour would move on to the next country. An ever-evolving enterprise, the ROCI exhibition was different each time it was presented, promoting peace and mutual understanding among diverse peoples.

To realize the project, Donald Saff, a print artist who had accompanied Rauschenberg on his 1982 trip to China, played a key role as the project's artistic director, performing multiple tasks such as fundraising, location hunting, and negotiation with officials of the targeted countries.[5] For both Rauschenberg and Saff, it was imperative to include China in the ROCI tour because the project was conceived there, whereas the choice of Japan and Malaysia needs some explanation. Those two countries actually sought the opportunity on their own. Japan, not a "sensitive area" by any means, was chosen because it offered to host ROCI and store Rauschenberg's work between ROCI China and ROCI Cuba.[6] Malaysia became part of the ROCI tour because Syed Ahmad Jamal, who was then president of the National Art Gallery in Kuala Lumpur, was a big fan of Rauschenberg and wanted to bring the ROCI exhibition to his country as its only venue in Southeast Asia.[7]

ROCI China

Among hosting countries in Asia, China was the first to receive the ROCI exhibition (in November–December 1985). The political climate seemed favorable for Rauschenberg at the time, as the exhibition fell during the "Culture Fever" period of the country's interest in Western art and thought. However, the requirements of the Chinese Exhibition Agency were stringent: Chun-Wuei Su Chien, a Baltimore-based Chinese woman who served as a coordinator, was to assume responsibility for the selection of the show's artworks and the production of its catalogue, and all correspondence on the subject would go through her.[8] Plus, the agency would review all works and video materials in advance, and Rauschenberg would be responsible for all expenses, including shipping, insurance, and the gallery rental fee of the National Art Museum of China.[9]

It was a daunting task to mount the first solo exhibition by a living Western artist in a country that had been culturally closed since the establishment of the People's Republic of China in 1949. In Beijing, Rauschenberg and his staff found the staff of National Art Museum of China "exceedingly cold" and unhelpful, with "lethargic and truculent" workers, and a gallery space in sorry condition:[10] its walls had never been repainted since the museum's 1962 opening as a showcase for idealized Chinese art and communist propaganda. Rauschenberg's team made an extraordinary effort to bring the space up to the standards he was used to in America.[11]

When it opened, the exhibition turned out to be enormously successful, drawing as many as 300,000 people. Rauschenberg's readymade-based and large-sized works, the exhibition's gigantic scale, occupying 7,380 square feet spread over four large galleries, and its multimedia presentation that used video screened on TV monitors, were all shocking and exciting to Chinese audiences craving contact with outside culture. Saff remembers their attraction to *Chinese Summerhall*, presented on the long arched wall, as being particularly intense. Responding to this observation, Rauschenberg commented, "They saw themselves. It gave them a chance to look at themselves without thinking of the boring patterns that were their existence."[12]

Artists from both inside and outside China's formal academies found the exhibition an eye-opening experience as well (the critic Li Xianting called its impact an "earthquake that sent shockwaves throughout China").[13] They found Rauschenberg's method an effective alternative to socialist realism and traditional art, and were inspired to experiment with readymades themselves.[14] For instance, Xu Bing, a young faculty member at the Central Academy of Fine Arts at the time, decided to stop producing works in the official style, later developing his signature style in which he treated Chinese characters as readymade forms to experiment with.[15] In addition, many aspiring artists outside Beijing made the trip to the capital explicitly to see the exhibition, which added significant momentum to the emerging avant-garde art scene called the "'85 New Wave Movement."[16]

Such a drastic artistic impact, however, combined with Rauschenberg's personal presence in Beijing, brought about resistance and conflicts as well, as his encounter with local unofficial artists revealed. As I have written elsewhere, this encounter took place at a private exhibition organized by painters engaged with gestural abstraction, a style deemed decadent and not permitted by authorities at the time.[17] Zhang Wei, a central figure of this underground community, recalled how the evening took an unexpected turn: First of all, Rauschenberg arrived late—and drunk (not unusual for the artist)—by a few hours. Second, when his team arrived, Chun-Wei Su-Chien proudly announced that the artist had just received a commission from *Time* magazine to create a portrait of Deng Xiaoping for its 1985 "Man of the Year" cover.[18] This did not please the young artists, who were obviously anti-government, and the evening ended on a sour note with a quarrel between Rauschenberg and Zhang Wei, who found the American artist's attitude condescending.

Be it enthusiasm or resistance, the local response was conditioned by the extreme socio-political differences between the U.S. and China, and the resulting cultural time lag that existed. In China in the mid-80s, engaging with abstraction was at once extremely radical and political, as Deng Xiaoping's open-door policy proceeded only gradually and with stringent regulations. Most likely, though, gestural abstraction by Zhang Wei and other underground painters in Beijing reminded Rauschenberg of Abstract Expressionism, whose influence he had struggled to overcome thirty years earlier. By the mid-80s, indeed, the contemporary art scene of the so-called Free World saw numerous trends and transitions, which, on the whole, resulted in the commercialization of art and the end of oppositional avant-garde art both as a concept and a practice.

ROCI Japan

How was ROCI received in Japan, then, the country that has been part of the Western Bloc since its defeat in WWII? As mentioned before, Japan was chosen as a convenient stop between ROCI China and ROCI Cuba. However, both Rauschenberg and Japan had another good reason to mount the exhibition there, because the artist had created a series of ceramic-based artworks in the country in 1982, right after his trip to China. Invited by the Otsuka Ohmi Ceramics Company, he visited Japan twice that year, to work at the company's factory in Shigaraki, a town in Shiga Prefecture famous for its ceramic production. During his first stay, he was presented with a new material: a large-scale ceramic panel of 2 cm (0.8 in.) thickness that came in two sizes, 90 cm x 250 cm (3 x 8.2 ft.) and 60 cm x 300 cm (approximately 2 x 10 ft.).

Although these panels were originally produced for use on building exteriors, Okuda Minoru, chief for the product's development, wanted to explore their artistic possibilities, calling them "art ceramic." Consulting the art critic Inui Yoshiaki, he came up with the idea to invite Rauschenberg to create new works with the panels, in collaboration with the company's chemist and technicians.[19] Accordingly, Okuda flew to the United States a few times to negotiate and obtain Rauschenberg's agreement. Initially, the artist worked on designs for *Japanese Clayworks*, a series of three-dimensional works into which he incorporated poles and ladders made of ceramic. Then, while waiting for them to be fired during the second stay, he made the series *Japanese Recreational Clayworks*, in which he transferred famous images from art history (such as the *Mona Lisa* and Botticelli's *Venus*) onto the ceramic panels.

Although Rauschenberg had worked with clay once in the 1970s, Otsuka Ohmi's large-scaled ceramic panels presented him with a new challenge. During his first stay, therefore, he spent most of his time exploring the material of clay and familiarizing himself with the company's technique, while taking photographs in Osaka and Kyoto to use for transfers. When the critic Inui met Rauchenberg after his photo-shooting trip, the artist was still unclear about the final

concept, saying, "A ceramic plate is still in a cool state." But he added immediately, "But soon, it will be hot." Interestingly, Inui noted at the time that the artist must have learned that "with clay he was free to make virtually any form he wished."[20]

Indeed, *Dirt Shrine* (below) the largest piece among the *Japanese Clayworks* series, consists of five ceramic plates of irregular shapes, incorporating objects such as a chained rock and a bamboo-shaped ladder that were cast in clay and fired. Further, the plate on the farthest left has a large tear in the upper area and a hole in the lower area, as if to challenge the flat, extremely hard material. Instead of using ceramic plates as a support for transfer, Rauschenberg thus used them as sculptural material to create shapes of his liking. Rauschenberg again made three-dimensional use of the panels for a series titled *Gates* (p. 34). By hinging the lower part of four of the five panels and attaching a bamboo-shaped ceramic pole to each of them from the back, he created a work of variable shape. As each of the four panels "opens" and "closes" with the hinge and the pole, the work assumes a different look each time it is installed, depending on which panel is open or closed. These innovative works certainly posed technical challenges for Otsuka Ohmi's staff. As Rauschenberg "never rested except for the time when he ate," the company responded enthusiastically to the

artist's vision, "stopping almost all work on other projects to focus their entire factory on his works, with twenty people working on this project for forty days."[21]

Production is one thing and reception is another, however. The impact of ROCI Japan, which opened at the Setagaya Art Museum in Tokyo in the fall of 1986, was rather modest. In 1964, when Rauschenberg first visited Japan, his work and presence had a strong impact.[22] But with Japan's economic growth during the intervening two decades, the issue of cultural time lag had largely been resolved, and the country had its own contemporary art scene and star artists. Accordingly, although ROCI Japan attracted over 17,000 visitors[23]—not a bad figure for a contemporary art exhibition in the country—the artist's idealistic agenda was received with a grain of salt in Tokyo.[24] Still, the relationship between Rauschenberg and Otsuka Ohmi seems to have been mutually beneficial. Rauschenberg's visit helped Otsuka's "art ceramic" gain recognition and offered a much-needed stimulus to the ceramic art scene in Shigaraki, where the plant was located. For his part, Rauschenberg expanded his reputation in Japan, soon afterwards receiving the Hiroshima Art Prize in 1992 for his efforts with ROCI's peace mission.

Dirt Shrine (North), 1982. Ceramics, 119 x 185 in. The Museum of Modern Art, Shiga

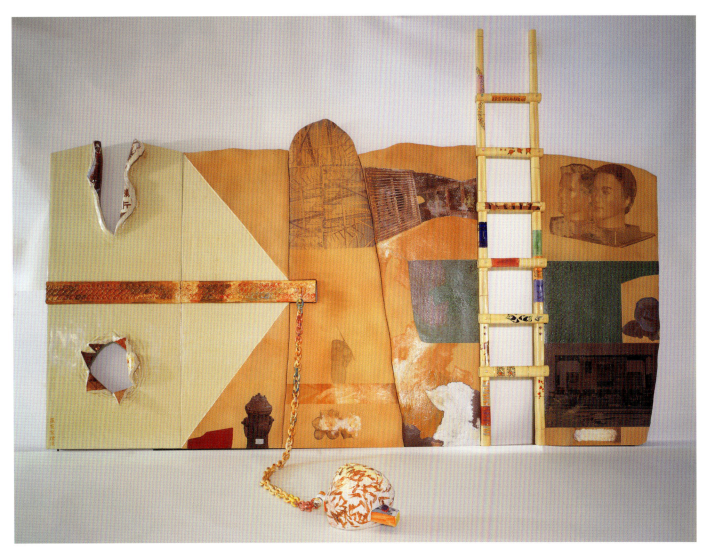

ROCI Malaysia

In Malaysia, unlike in China, people were not entirely disconnected from the rest of the world. Yet, unlike in Japan, they were not under heavy influence of American art and culture, either, as the country was a former British colony. As mentioned earlier, Syed Ahmad Jamal, president of the National Art Gallery, played a key role in bringing the ROCI tour to the country. As an artist trained in England and in the United States, Jamal was respected as the first abstract painter in Malaysia. He thought highly of Rauschenberg because of the American artist's engagement with socio-political aspects of contemporary life. Hearing about Singapore's interest in the ROCI project, Jamal acted to bring it to Malaysia, in part because of the cultural rivalry between the two countries.[25] Situating the ROCI exhibition as a major part of Prime Minister Mahathir Mohamad's 1990 "Visit Malaysia Year" campaign to improve the country's international status, Jamal secured the budget of 2.5 million rupees needed to renovate Hotel Majestic, where the National Art Gallery was located at the time.

As in China, a solo exhibition of this scale by a living Western artist was unheard of in Malaysia. Rauschenberg's works arrived in Kuala Lumpur in three containers that were so big and heavy they blocked traffic and caused a jam. Adding to the chaos, the roads were steep and narrow and drivers had difficulty reaching their destination. Installing the show at the Hotel Majestic was not an easy task, either. Ismail Yacub and Azidi Amin, respectively assistant

curator and the official photographer of the museum at the time, recalled the Rauschenberg crew "showed off" their equipment and told the museum staff "not to touch anything." This created tension, and it was only two days before the opening that Rauschenberg's team finally asked for help. Jamal told them to place each work on the floor before the desired wall and then go back to their hotel. When they returned the next morning the exhibition was perfectly installed, a feat that is still a legend at the museum today.[26]

As it happens, many of the works included in ROCI Malaysia did not incorporate Malaysian materials or technique. Those that did were mainly silkscreen paintings embedded with photographs he had taken during his pre-ROCI preparation trip to Malaysia in 1989. *Yang Teragong* (*Malaysian King,* opposite), a large work Rauschenberg donated to the National Art Gallery on the occasion of ROCI Malaysia, features flags of Malaysia's thirteen states, but the artist had not picked those materials himself. The museum staff had to send them to the United States after his preparatory trip so he could make a work in time for the ROCI exhibition.[27] As Malaysian people had access to information about postwar American art in libraries of the British Council, the museum staff and artists I interviewed in 2011 generally found ROCI works somewhat less impressive than his early work. The exhibition

Gate (North), 1982. Ceramics, 97¼ x 167¼ in. The Museum of Modern Art, Shiga

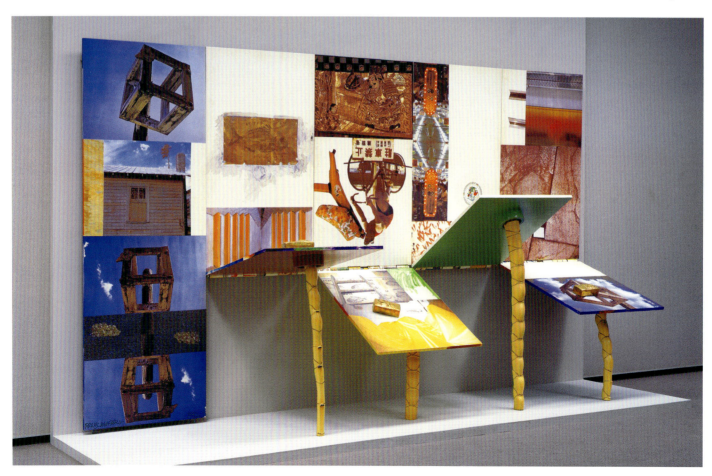

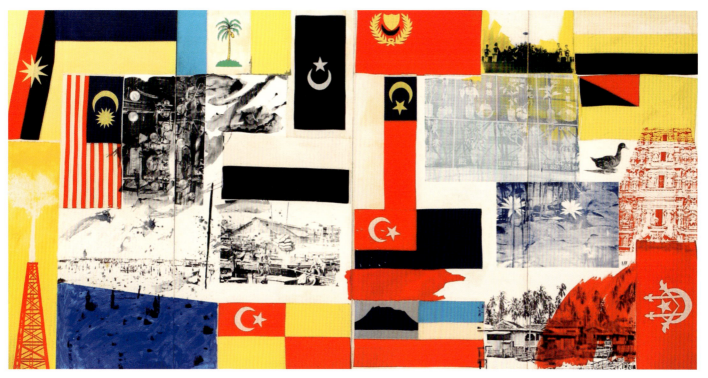

Yang Teragong (***Malaysian King***), 1990. Acrylic and collage on plywood panels, 99¾ x 198½ x 3 in. National Art Gallery, Kuala Lumpur

was publicized well and drew more visitors than usual, but did not necessarily appeal to a larger public. In fact, the Islamic Arts Museum Malaysia nearby happened to hold a concurrent exhibition celebrating the life and legacy of Muhammad, which was a huge blockbuster and overshadowed Rauschenberg's exhibition. Accordingly, Thomas Buhler, who served as a project curator for ROCI Malaysia, saw the exhibition as being less successful than at other venues.[28]

However, ROCI Malaysia did leave a significant mark in conjunction with the local development of contemporary art. Since 1974, the National Art Gallery had held an annual "Malaysian Young Contemporaries Competition," and its theme for 1988 was "materials and creation," for which many applicants entered assemblage works made of Malaysian materials such as bamboo and batiks.[29] With assemblage having recently become part of their contemporary art vocabulary, Malaysian artists were well prepared to see Rauschenberg's art. As observed by Amerrudin Ahmad, conservator of the National Art Gallery, the ROCI Malaysia exhibition held two years later served as an official endorsement of the mixed media approach, prompting all the students at two national schools, Malaysia Institute of Art and Institute of Technology Malaysia, to see the show to gain a first-hand understanding of the technique of "assemblage" from one of its pioneers. As the method was thereafter taught at art schools and collectors started buying the works, a commercial market gradually emerged for them.[30] ROCI 's impact in Malaysia may not seem as dramatic as it had been in China but was, in fact, far greater than it had been in Japan.

As outlined in this essay, ROCI's legacy in Asia was somewhat ambivalent. The project basically had the same structure everywhere it toured, but the situation of the hosting country varied, conditioning ROCI's reception in each locale. In China, which was experiencing dramatic social reform after the Cultural Revolution, its presence was most impactful, inviting both enthusiastic reception and surprising resistance. Japan, on the threshold of a bubble economy, did not see the American artist's work as being so inspirational as it had two decades before. Malaysia was trying to improve the country's status in the international community and appropriated the ROCI tour as part of such efforts.

At the same time, Asia's impact on Rauschenberg must also be considered, as Asian cultures had significant influence on the artist's creation. In particular, the five weeks he spent in China in 1982 must have been unforgettable, as he discovered the everyday life and culture of Asia before modernization or Westernization. Just as ROCI China changed the course of many Chinese artists' careers in 1985, the country had changed Rauschenberg's life three years before, in 1982. This experience seems to have stayed with the artist long after the conclusion of the ROCI project. In fact, the last graphic series he created before his passing in 2008 was titled the *Lotus* series, which consists of prints incorporating photographs he had taken in China in 1982 (pp. 36, 37, 53). The series signals a continuing dialogue Rauschenberg had with Asian cultures until the end of his artistic career.

Endnotes

In this essay, Chinese and Japanese names are given in traditional order: surname followed by first name (e.g. Zhang Wei, Okuda Minoru).

[1] This project was originally conceived by Stanley Grinstein, co-director of Gemini G.E.L., who had an idea for Rauschenberg to work with Chinese paper.

[2] The work was created with Graphicstudio II at the University of South Florida. For *Chinese Summerhall* and photographs Rauschenberg took in China, see also Felicia Chen, "China through Rauschenberg's Lens," in *Rauschenberg in China*, exh. cat. (Beijing: Ullens Center for Contemporary Art, 2016), pp. 137–143.

[3] Robert Rauschenberg and Donald Saff, "A Conversation about Art and ROCI," in Mary Yakush, ed., *ROCI: Rauschenberg Overseas Culture Interchange* (Washington, DC: National Gallery of Art, 1991), p. 162.

[4] Ibid., pp. 162–63. On this occasion, Rauschenberg and Donald Saff gave them a lecture on Western modern art because they found students at Central Academy of Fine Arts hungry for information about it.

[5] For the logistics of ROCI and the project on the whole, see Hiroko Ikegami, "Art Has No Borders': Rauschenberg Overseas Culture Interchange," in Leah Dickerman and Achim Borchardt-Hume, eds., *Robert Rauschenberg* (New York: Museum of Modern Art, 2017), pp. 340–349.

[6] Rauschenberg and Saff, "A Conversation about Art and ROCI," p. 171.

[7] Syed Ahmad Jamal, interview by author, May 4, 2011, Kuala Lumpur.

[8] Chun-Wuei Su Chien, "Rauschenberg Overseas Culture Interchange in China (Beijing and Lhasa)," unpublished memoir, n.p., March 26, 1986. Robert Rauschenberg Foundation Archives. Chun-Wuei Su Chien took up the coordinator job as she had acted as Rauschenberg's coordinator and translator in 1982.

[9] "An Agreement between the China Exhibition Agency and the Evergreen Cultural Exchange for the Rauschenberg Overseas Culture Interchange Exhibition in China." Signed December 3, 1984, with its addendum signed on May 1, 1985. Museum rental fees totaled $26,000. Robert Rauschenberg Archives, New York.

[10] Donald Saff, "An Incomplete History of Rauschenberg Overseas Culture Interchange," unpublished and unpaginated interim report penned by Saff in 1987. Robert Rauschenberg Archives, New York.

[11] Chun-Wuei Su Chien brought with her "rollers, trays, and 2,000 RMB [Renminbi, Chinese currency]" to paint the walls. Chun-Wuei Su Chien, letter to Donald Saff and Terry van Brandt, July 22, 1985. Robert Rauschenberg Archives, New York.

[12] Rauschenberg and Saff, "A Conversation about Art and ROCI," p. 162.

[13] Li Xianting, "Rauschenberg and Chinese Modern Art's Historic Opportunity," *Robert Rauschenberg: The Lotus Series*, exh. cat. (Beijing: Da Feng Gallery, 2008), not paginated.

[14] Li Xianting, interview by author, July 21, 2009, Songzhuang.

[15] Xu Bing, interview by author, July 27, 2009, Beijing.

[16] For this movement, see Gao Minglu, ed., *The '85 Movement: The Enlightenment of Chinese Avant-Garde* (Guilin: Guangxi Normal University Press, 1988), and *The '85 Movement: An Anthology of Historical Sources* (Guilin: Guangxi Normal University Press, 2008). These publications are in Chinese.

[17] Hiroko Ikegami, "ROCI East: Rauschenberg's Encounters in China," in Cynthia Mills, Lee Glazer, and Amelia Goerlitz, eds., *East-West Interchanges in American Art: A Long and Tumultuous Relationship* (Washington, D.C.: Smithsonian Institution Scholarly Press, 2012), pp. 174–187.

[18] Zhang Wei, interview by author, July 23, 2009, Beijing.

[19] Okuda Minoru, interview by author, July 14, 2009, Shigaraki. The idea of "art ceramic" came about partly because the materials did not sell as well as expected, due to the oil shock crisis and the subsequent recession in the 1970s.

[20] Inui Yoshiaki, "Rauschenberg and Shigaraki," in *Robert Rauschenberg: Shigaraki* (Osaka: Otsuka Ohmi Ceramics, 1986), p. 51. I adapted the English translation found in this catalogue.

[21] Ibid.

[22] See Chapter Four in Hiroko Ikegami, *The Great Migrator: Robert Rauschenberg and the Global Rise of American Art* (Cambridge, Mass.: MIT Press, 2010).

[23] "Annual Report of the Setagaya Art Museum, 1985–1986," published in 1988, p. 31. The actual attendance reported was 17,397.

[24] For instance, see Minamishima Hiroshi, "Raushenbāgu ten: Owari naki kaiga eno ukai" [Rauschenberg Exhibit: Endless U-Turns toward Painting], *Bijutsu techō*, no. 572 (December 1986), pp. 152–159.

[25] Zanita Anuarm, "The Artist, the Overseer," *Syed Ahmad Jamal: Pelukis* (Kuala Lumpur: Balai Seni Lukis Negara, 2009), pp. 482–83. After separating from Malaysia to become an independent city-state in 1965, Singapore had become quite wealthy by the late 80s.

[26] Ismail Yacub and Azidi Amin, interview by author, May 5, 2011, Kuala Lumpur.

[27] Ismail Yacub, interview by author, May 5, 2011, Kuala Lumpur.

[28] Thomas Buhler, conversation with author, February 14, 2011, New York.

[29] Azidi Amin, interview by author, May 5, 2011, Kuala Lumpur.

[30] Amerrudin Ahmad, interview by author, May 5, 2011, Kuala Lumpur.

The lotus symbolizes enlightenment or purity in several Asian cultures, and Rauschenberg identified this symbolic element as the central component for the series. Among the very last prints completed by the artist before his death in 2008, the *Lotus* series serves as an elegy; a visually stunning reminder of his embrace of communal practice and constant reflection—perhaps even expressing his own hopes for enlightenment towards the end of a full life.

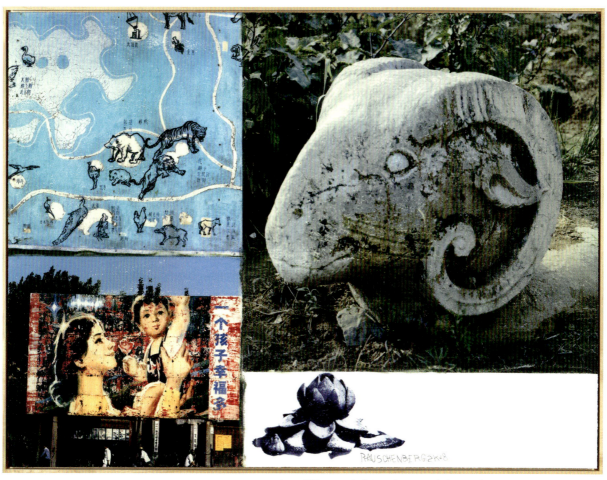

Lotus X (*Lotus* series), 2008. Pigmented ink-jet with photogravure, 45¾ x 60¾ in.

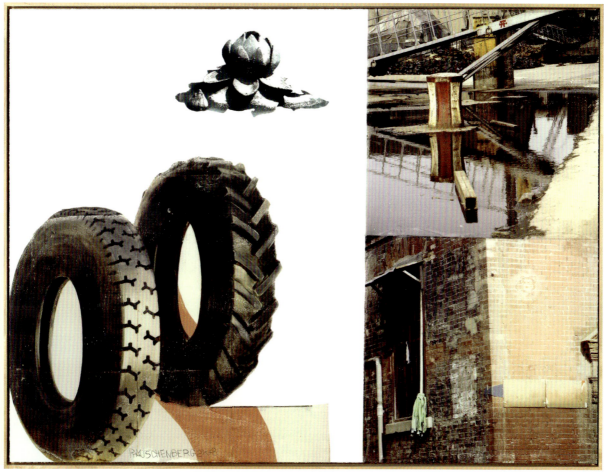

Lotus II (*Lotus* series), 2008. Pigmented ink-jet with photogravure, 45¾ x 60¾ in.

Rauschenberg in Tibet: Reflections from the Artists

Sarah Magnatta, PhD

In the 1980s, Robert Rauschenberg traveled to both Lhasa and Beijing to promote a global cultural exchange—a lofty goal, considering the difficult histories and ongoing political tensions of both regions. Although the economic policies implemented in 1978 by Chinese politician Deng Xiaoping had opened up the cities to foreign businesses, the everyday realities of the restrictive nature of the Communist Party of China (CPC) prevented much global cultural interaction. The Rauschenberg Overseas Culture Interchange (ROCI) project was groundbreaking not only in its scope (the artist traveled to ten countries over the span of eight years), but also due to its self-funded nature. Robert Rauschenberg sold off many of his own artworks and other works in his collection to fund the travels, thereby avoiding any political or social restrictions that could occur with grant-funded or commercially-funded projects.[1] The artist created work inspired by local materials or processes, held a ROCI exhibition at each site, and then incorporated those experiences and work into the next ROCI site. The result of this repetitive process (albeit in novel environments) was a constant reflection on Rauschenberg's own work as well as the cultural interchanges he made throughout his journey.

Rauschenberg's reflections on his travels abroad are not just apparent in his ROCI works; he contemplated these experiences throughout his artistic career. His final print series, *Lotus* (2008), incorporates several photographs from his time in China. Though Rauschenberg's memories are well documented, the reflections of the artists he worked with or encountered are not as readily available. I contacted three Tibetan artists who were in Lhasa and/or Beijing during Rauschenberg's projects and exhibitions to hear their versions of ROCI events.[2]

Nortse

Born Norbu Tsering in 1963 in Tibet, Nortse (as he is commonly known) studied at various schools, including Tibet University in Lhasa, the Central Academy of Fine Arts (CAFA) in Beijing, and art academies in Guangzhou and Tianjin. Nortse experiments with traditional Tibetan and Buddhist forms and imagery; his use of mixed media and concern for contemporary issues pushes the boundaries of those traditions. Nortse's works have been exhibited in solo and group exhibitions in China, Europe, and the United States and are held in public and private collections worldwide.

Below and opposite: Nortse, **Thirty Letters**, 2009. Metal, steel and sand, 23½ x 31½ x 74¾ in. Photographs courtesy of Rossi & Rossi and the artist

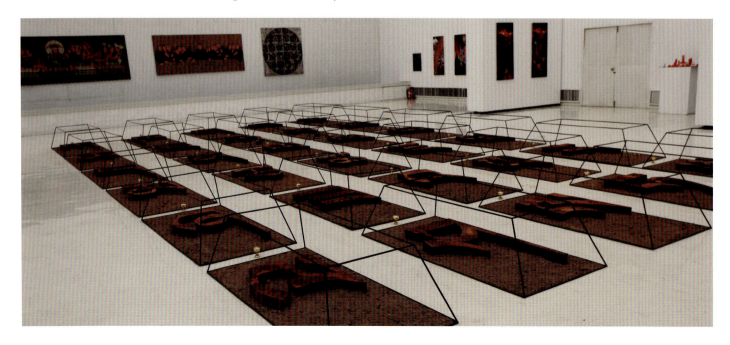

SM Do you remember Robert Rauschenberg visiting Lhasa?[3]

N It was in 1985, I was 25 at the time. I just returned from my studies at Guangzhou Academy of Fine Arts and was fortunate enough to make it on time for Rauschenberg's solo exhibition in Lhasa. It was my honor to participate as a volunteer at Rauschenberg's revolutionary exhibition and I had a chance to curate my own exhibition at the venue. Rauschenberg's show included an opening ceremony and encouraged a lively artistic dialogue and other activities.

SM What was your first impression of Rauschenberg?

N An unidentified flying object landing in Lhasa! Of course, this is just a metaphor, but it certainly encapsulates my memorable impression of the time.

SM Did Rauschenberg impact your creative process, and if so, how?

N I was a student at Minzu University of China, Beijing, when I encountered catalogues on western modern art in the school's library. Then, I became fervent in experimenting with this new artistic approach in painting. It was 1985 in Lhasa when I personally witnessed the completed works of Robert Rauschenberg through an expansive exhibition. There, I had an intimate encounter with the most innovative western contemporary art. It left me with a mixture of curiosity, confusion, surprise, all of which captivated me … it certainly changed my artistic thinking and approach in my creative and artistic process.

The first contemporary artworks I came to know are works by Rauschenberg. Many of his works were made with mixed media, such as collage, use of readymade objects, etc.; such an approach had a huge impact on my creative thinking later on. *Thirty Letters*, 2009 (opposite) and *Book of Ashes*, 2015 (p. 40) reflect Rauschenberg's influence on me in terms of the media and the creative process of these works.

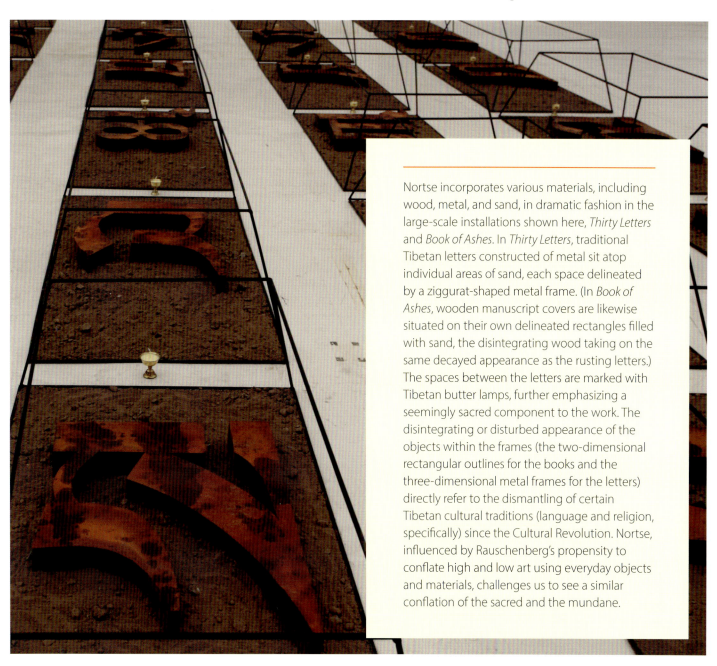

Nortse incorporates various materials, including wood, metal, and sand, in dramatic fashion in the large-scale installations shown here, *Thirty Letters* and *Book of Ashes*. In *Thirty Letters*, traditional Tibetan letters constructed of metal sit atop individual areas of sand, each space delineated by a ziggurat-shaped metal frame. (In *Book of Ashes*, wooden manuscript covers are likewise situated on their own delineated rectangles filled with sand, the disintegrating wood taking on the same decayed appearance as the rusting letters.) The spaces between the letters are marked with Tibetan butter lamps, further emphasizing a seemingly sacred component to the work. The disintegrating or disturbed appearance of the objects within the frames (the two-dimensional rectangular outlines for the books and the three-dimensional metal frames for the letters) directly refer to the dismantling of certain Tibetan cultural traditions (language and religion, specifically) since the Cultural Revolution. Nortse, influenced by Rauschenberg's propensity to conflate high and low art using everyday objects and materials, challenges us to see a similar conflation of the sacred and the mundane.

Tsewang Tashi

Tsewang Tashi was born in 1963 in Lhasa, Tibet. He was a founding member of the Gedun Choephel Artists' Guild, a revolutionary contemporary artists' group based in Lhasa. He graduated from the Fine Arts Department at the Central Institute of Nationalities (Minzu University of China, MUC) in Beijing before receiving his MA from the National College of Art and Design in Norway. He is an Associate Professor in the Arts Department at Tibet University and exhibits works internationally, including in galleries in Beijing, New York City, London, and Hong Kong. Tashi is inspired by the realities of contemporary life in Tibet, saying "What I pay attention to is to the real people and environment as my source of inspiration. I believe that if contemporary life around us is ignored, real contemporary art cannot be created."

SM Do you remember Robert Rauschenberg visiting Lhasa or Beijing? [4]

TT Yes, it was a very important show and one of the biggest contemporary art exhibitions in China when I was in Beijing. We were educated in the Fine Arts Department of the Central Institute of Nationalities (MUC) in Beijing, and its art education was very much influenced by the former Soviet Union and Xu Beihong's concept of art education that very much emphasizes painting from nature, and a more realistic sensibility in general. Even abstract art and Kandinsky were not possible to learn or teach at the school

at that time. This was the same in other art schools in China. But China already started the open-door policy and many new things came at that point. Often, art education did not follow the new development in China. Therefore, Rauschenberg's exhibition was a shocking experience for many others and me.

SM What was your first impression of Rauschenberg?

TT I had just graduated from the Central Institute of Nationalities (MUC) in Beijing and was a young art teacher when Rauschenberg's exhibitions took place in Beijing and Lhasa in 1985. Rauschenberg's artworks completely broke the concept of art as we knew it at the time. So, for me, it was a point of new understanding of art beyond modernist art, such as abstract art, expressionism and so on.

Nortse, **Book of Ashes**, 2015. Beech wood, acrylic and paper; 40 pieces, each approx. 4¼ x 27½ in. Photographs courtesy of Rossi & Rossi and the artist

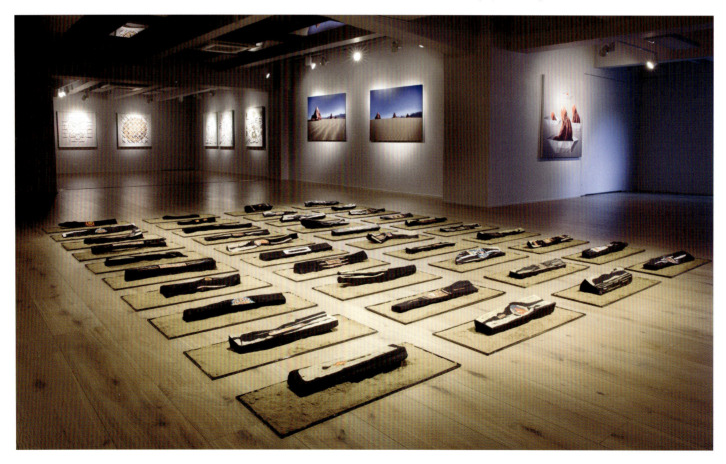

SM Did Rauschenberg impact your creative process, and if so, how?

TT Rauschenberg freely used multiple mediums, form, and space. And his works were also very open in subject matter. This was a mind-opening experience for me. Not long afterwards, I started to do some works which were actually inspired by him, such as *Snow Land*, *Untitled* and some others made in the 1980s. In these works, I started to do collage. I combined different subjects and different spaces in my works, but at the same time, the works were based on my own experiences.

Gonkar Gyatso

Gonkar Gyatso was born in 1961 in Lhasa, Tibet. He studied painting at the Central Institute of Nationalities (MUC) in Beijing before receiving his MA in Fine Art from the Chelsea College of Art and Design in London. Gyatso often juxtaposes seemingly contradictory forms, such as buddha figures constructed entirely out of pop-culture images. Gyatso's work, including his self-designed stickers, reflects his interest in blurring the line between high and low art. The artist has exhibited works in dozens of international museums and galleries, including the Venice Biennale, the Boston Museum of Fine Arts, the Chinese National Art Gallery in Beijing, and the Metropolitan Museum of Art in New York City.

SM Do you remember Robert Rauschenberg visiting Lhasa? [5]

GG I was in Lhasa teaching at Tibet University when Rauschenberg came to do the show. At that time, Lhasa was not a big city and the university and museum were not far from each other; I used to work there before I went to college in Beijing. Lhasa was such a small city and we didn't even know about the exhibition beforehand. I remember just before, probably just two or three days before the opening, we started hearing something about the exhibition. I remember one of the men who worked at the museum was very taken by Rauschenberg's requirement to have the displays cleared from every corner, every angle, and every edge of the wall space. It had to be really clean and white, which was not quite the requirement before! The other thing we heard was that Rauschenberg bought a dead pig from somewhere near the museum because he said he was going to make it art, so that was something that was kind of amusing!

SM What was your first impression of Rauschenberg?

GG I remember the opening was very well attended, and also there was an official speech and celebration. We all came to the show. At first it was like a little fun fair. Then, one day, he was invited to our show, which was a group of

Tibetan artists in another space. He came to see the show and after he saw our works we had a little conversation. I remember one of the first questions he asked was "aside from painting, do you do anything else?" I think we said "yes," maybe there are one or two sculptors, but most of the artists just do painting. I remember at that time I thought that was a strange question.

SM Did Rauschenberg impact your creative process, and if so, how?

GG Until he came to Lhasa, we didn't know about Rauschenberg even though in Beijing we did study western art history for four years. I don't think his work influenced me then … it took me quite a long time, I think until I came to New York in 2006 or 2007. Then, there was kind of a slow understanding for me about his ideas and his work.

———

Rauschenberg himself reflected often on the ROCI program; the memories of the people and places the artist encountered are found throughout his later prints and works. It was a decade that he returned to repeatedly—a period of cultural interchange that is summed up by the artist himself:

I feel strong in my beliefs, based on my varied and widely traveled collaborations, that a one-to-one contact through art contains potent peaceful powers, and is the most non-elitist way to share the exotic and common information, seducing us into creative mutual understandings for the benefit of all. [6]

Endnotes

[1] Robert Rauschenberg as quoted in *Rauschenberg Overseas Culture Interchange* exhibition catalog (Washington: National Gallery of Art, 1991), p. 157. Rauschenberg refused sales in any of the ROCI countries, again avoiding the business aspect of the art world in favor of a focus on the creation of work and the connections made.

[2] The ROCI Tibet project was exhibited at the Tibet Revolutionary Hall in Lhasa in 1985.

[3] The ROCI China project was exhibited at the National Art Museum of China in 1985. Interview conducted via e-mail on 22 January 2019. Thank you to Ashley Shen for arranging and translating this interview.

[4] Interview conducted via e-mail on 8 November 2018.

[5] Interview conducted via WeChat on 31 August 2019.

[6] Robert Rauschenberg as quoted in *Rauschenberg Overseas Culture Interchange* exhibition catalog (Washington: National Gallery of Art, 1991), p. 154.

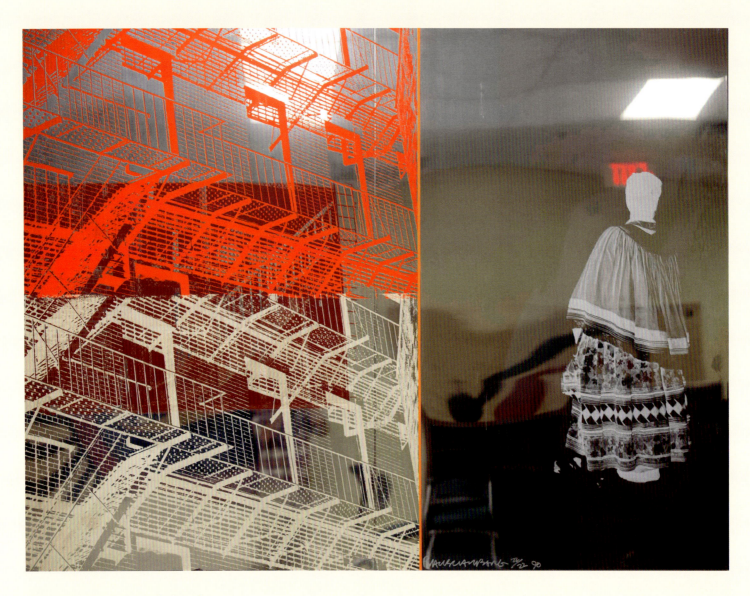

As Poetic as a Brush Stroke

Rauschenberg continued his almost anthropological exploration of American culture in his *ROCI USA* series of the early 90s. For many of these works, he incorporated photographs via the silkscreen process, often printing on reflective metals. This new method—especially when enhanced by the use of molten, colored waxes in place of traditional ink (the "Fire Wax" method), allowed various textures to remain on the image. Sometimes these textures appeared similar to the "Ben Day" dots familiar from newspaper and magazine photos. Elsewhere, the squeegee used in inking the silkscreen itself made brush-like marks on the print.

As Rauschenberg said, *The image that is made by a printer's mat, a metal plate, a wet glass or a leaf plastically incorporated into a composition and applied to the stone stops functioning literally with its previous limitations. They are an artistic recording of an action as realistic and poetic as a brush stroke.*

Above: *Seminole Host* (*ROCI USA/Wax Fire Works* **series**), 1990. Acrylic and fire wax on mirror polished stainless steel, 72¾ x 96¾ in.

Opposite: *Pegasits* (*ROCI USA/Wax Fire Works* **series**) 1990. Acrylic, fire wax and chair on stainless steel, 72¾ x 96¾ x 17½ in.

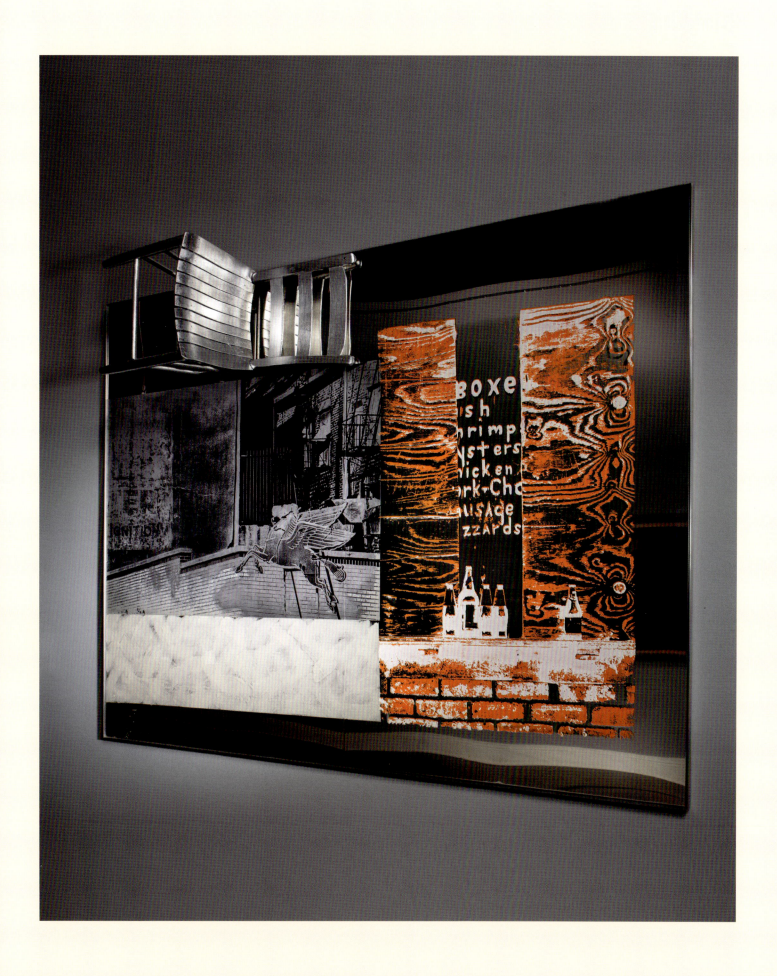

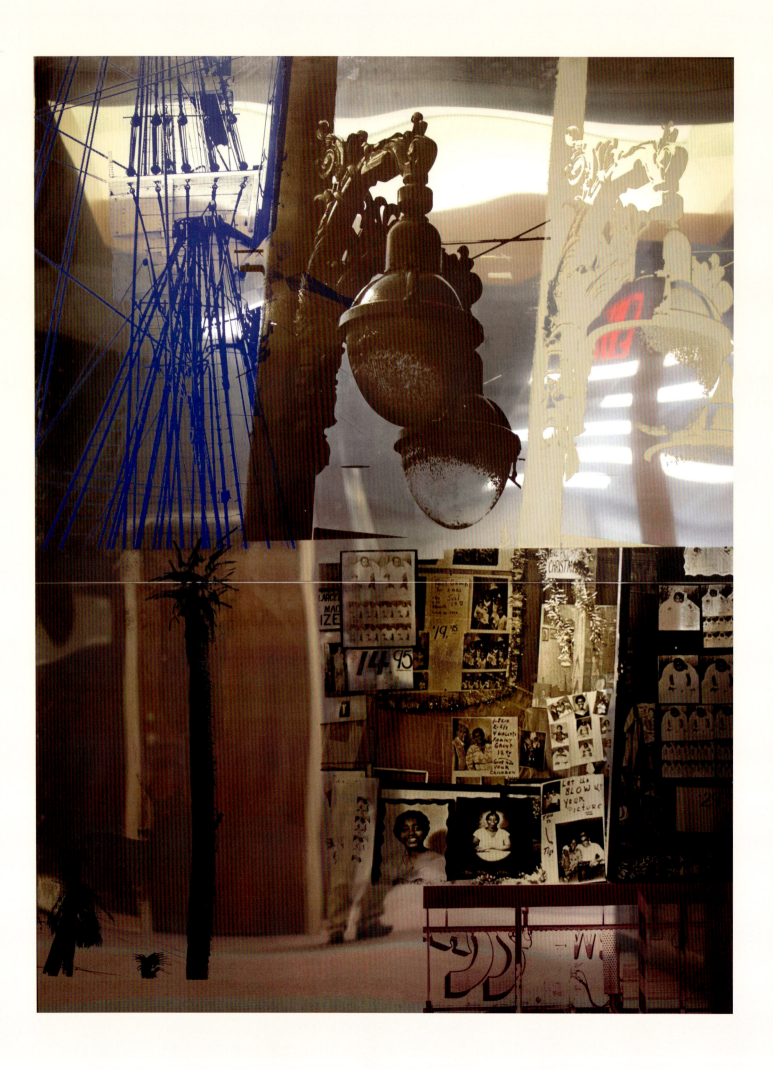

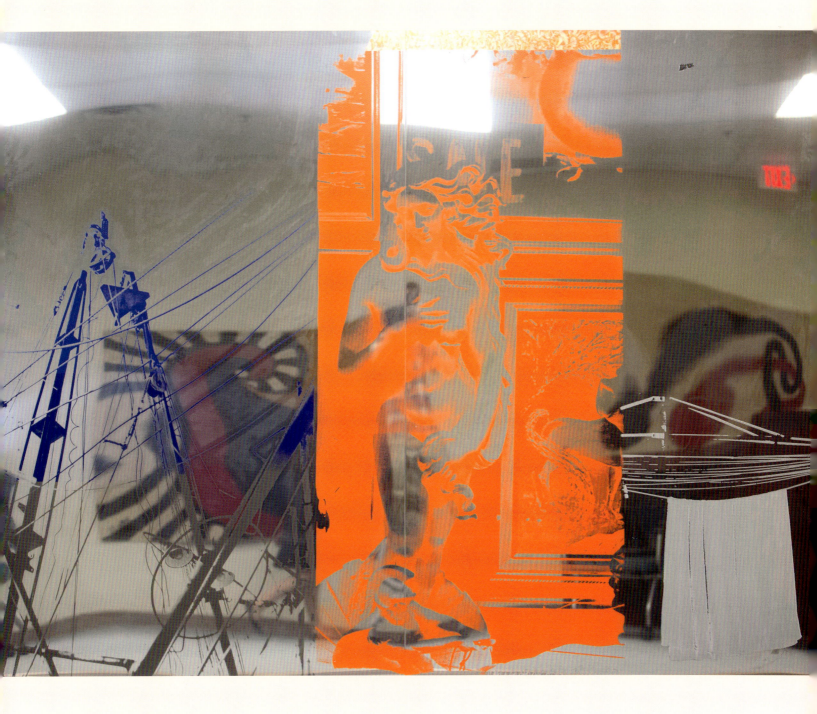

Swim (*ROCI USA/Wax Fire Works* **series**), 1990. Acrylic, fire wax, and variegated brass leaf on mirrored aluminum, 72½ x 96¾ in.

Opposite: *Narcissus* (*ROCI USA/Wax Fire Works* **series**), 1990. Acrylic, enamel, and firewax on mirrored stainless steel, 96¾ x 72¾ in.

Swim presents a well-known masterpiece by Sandro Botticelli (*The Birth of Venus*, 1480) in garish safety orange, floating between a bright blue oil rig and a laundry line. This "flattening" of high and low culture into one continuum was a signature move of Pop artists, but Rauschenberg used this method both before and long after the peak of that movement in the 1960s.

In a more contemplative mood, *Narcissus* (opposite) refers to the ancient story of a foolish young man who falls in love with his own reflection. Our eyes are drawn to the surface of the image, enjoying the array of colors and patterns, but we quickly become aware of our own presence as the reflective surface merges us into the picture.

Recycling

Printing was the perfect medium for Rauschenberg's drive to re-use images, objects and ultimately, memories themselves. He often returned to his own earlier works and recycled them in printed form, as he did in *Sketch for Monogram* (below) by reproducing the notebook page where he first sketched out his famous "Combine" of 1954–59, *Monogram*. By "recycling" the image as a print, Rauschenberg not only made *Monogram* more accessible, he also mirrored the original strategy of the sculptural piece, which was composed of found objects.

Many of his works are concerned with reflecting old images, objects, and memories, often using printing-inspired techniques in their re-creation.

At first sight an unusual experiment in hard-edged minimalism (with a nod to his own famous *White Paintings* of the 1950s), the hybrid painting/sculpture *Score*, from the *Off Kilter Keys* series (below), actually bridges minimalism with travel-photo snapshots. For Rauschenberg, even a blank canvas must always be infused with memory and experience.

Right: *Hog Chow* (*Chow Bags* series), 1977. Screenprint on paper with collage, 48⅛ x 36⅜ in.

Opposite: *Sketch for Monogram*, 1973. Lithograph and screenprint, 12 x 9 in.

Below: *Score* (*Off Kilter Keys* series), 1993. Acrylic enamel on aluminum, 60 x 88 x 7½ in.

An Interview with Master Printer Bill Goldston

Dan Jacobs

Bill Goldston, director of Universal Limited Art Editions, spoke with me in November 2019. Goldston came to U.L.A.E. as a printer in 1969, and over the course of many years he and Rauschenberg developed a close friendship and working relationship. The interview has been edited for clarity and length.

A Higher Level of Awareness

Bill was insistent on establishing Rauschenberg's way of being before he would discuss methods and technique. For example, when I asked him about Rauschenberg's use of found objects, he surprised me with what at first seemed like an unrelated anecdote.

BG A friend of mine, another artist, is a Buddhist monk. And he was asked if he would show a high-level Tibetan lama around Los Angeles, do interesting things, and take that person for dinner, and do that sort of stuff. And so they went to a restaurant, and there were about eight more monks that were traveling with them.

When they got to this restaurant, this lama figure ordered a very large steak. And when the steak came, he cut it into little pieces, which he then put on each of these persons' plates, just to share with them. When it came to putting one on the plate of my friend, my friend said, "But sir, I'm a vegan, I don't eat animals out of respect for their lives." And he said, "On the contrary, what you want to do is eat that animal's meat so that you can bring that animal to another, higher order of awareness."

I think of that a lot, about what Bob picked up and what he used in his work. He tended to pick up things that were mundane from one side of the question, and from the other side, very interesting works of art.

Turning to Rauschenberg's general approach to work, Bill recounted the following late-night exchange in the artist's studio:

BG Sometimes I'd just be there and he'd be working on a painting … picking out images and things. … So I said to him, "Tell me, how do you know what you're going to do in

a painting? How do you start a painting? What drives you to start a painting?" And he looked at me and he said after a while, "Well, there is this guy Rauschenberg, and he shows up to the studio and he tries to make paintings, and I simply go along and I try to help him." My next question was, "How do you know when you've finished it?" … And he said, "When I see the next one ready to be made."

DJ It's like the two of you were both working for this guy named "Rauschenberg," right?

BG [Laughing] He goes around and he starts picking up screens, and laying them down, and I just try to help him out!

Rauschenberg as Printmaker

I asked Bill if Rauschenberg was a "natural" in the print medium, or if he'd had to guide him to an understanding of some of the complexities of the medium:

BG No, never. We didn't work that way together.

DJ How did you work?

BG Well, he had a saying, which I really like: "It's not what we started out to do, but it's a lot better." And with that approach, we were always in search-and-explore mode, and we just captured it at some point so that we could print it in an edition. So, everything was fair game. And to be honest with you, Jasper Johns, (who also worked at U.L.A.E. with Tatyana Grossman starting in the early '60s, as did James Rosenquist and Jim Dine) is a little bit like that too. You can be free and open and say, "This is where we want to be." And then you capture that. Both of them were that way: you go to work, you develop something, and it's truly an exploratory process.

… I came to LA because I had developed a way of transferring magazines to lithographic stones. When I first met Bob in the summer of '69, my job was to figure out how to put photo images on stones, and then we were going to print those. These were based on his Dante transfer drawings and those drawings were just—I mean, I saw those and I thought, My God! This is what it's really all about. So, we were using materials that were for another medium completely, using them in lithography, and we just had the good luck of

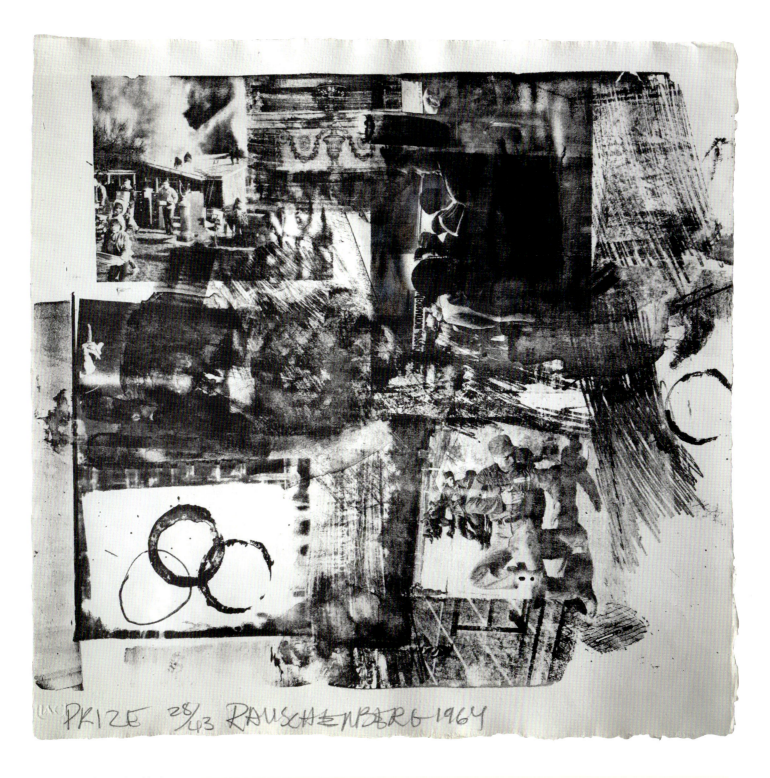

Prize, 1964. Lithograph in black on white laid paper, 15⅜ x 16¼ in.

Transfer Drawings *Prize* is one of seven lithographs included in Rauschenberg's *XXXIV Drawings for Dante's Inferno*, published in 1965. The book reproduced his original drawings on the subject, completed in 1959–60. These drawings were made using a wet transfer process, in which Rauschenberg placed moistened, pre-printed materials (like newsprint and magazine clippings), face-down on watercolor paper to transfer some of the ink to a blank sheet.

Prize is one of seven loose-sheet lithographs, inspired by the earlier drawings, that were inserted into a limited number of the books. He used traditional litho stones and oil-based inks for these prints. Later in his career, he would help adapt aspects of the wet transfer process used for the *Dante's Inferno* drawings into the preparation of lithographic plates for printing.

making it work and we had such a great time that summer. And it was just fabulous. … I didn't come as some sort of technician to him ever. I came as, "Let's try this and see how it works." And that's sort of the way our relationship was for 50 years.

"We're going to use it anyway."

In 1996—thirty-four years after creating a stir by printing from a broken stone for the lithograph, Accident (p.20)—*Rauschenberg continued to show the same noteworthy flexibility. Goldston tells the story of how a cameraman's embarrassing mistake was cheerfully incorporated into the 1997 print,* Back-up. *A documentary film crew had crowded into the darkroom with the whole printing team. A sheet of Lexan had just been exposed with an image selected by Rauschenberg, and was ready for him to apply developing fluid:*

BG Bob was getting ready… He was standing with a brush in his hand, and the developer in the other hand. And he stuck the brush into the developer, and all of a sudden the lights came on in the darkroom a second, and the camera man said, "What the f--- !?" and turned off the lights and ran out of the darkroom. And, of course, Bob and I knew what had happened because the film had been exposed to light. It was was just going to go black. So, I said to Bob, "You know it's ruined." He said, "I know, but we're going to use it anyway." And he started painting on it with the brush. He made the image that you see on top of

Backup printed in white ink. He painted that film using developer, and put images on top of it. That's the kind of creative person you are dealing with here. … I wish everybody had got to meet him. He was an absolutely amazing human being—one of a kind—one of a kind.

An Eye for junk

Rauschenberg's sets for choreographer Trisha Brown's performance of Lateral Pass (below) *in Naples, Italy in January 1987, were held on board a ship in harbor by Italian officials and had to be replaced on short notice. Goldston tells about the process of gathering materials for the new sets:*

BG Bob said, "Well, we'll just do another one, we'll make one." So, there was a gallerist there in Naples, Lucio Amelio, who was representing Bob's work. He said, "Well, what are we going to do?" and Bob said, "Let's go to the junk yard." … We had two station wagons. My wife and I had one, and Lucio had another. Well, we get to this pile of rubble. I mean, it's enormous and there's stuff everywhere. And so we're all going around picking up objects, and showing them to Bob … and Bob would look at it and say, "No, that's terrible." He would pick up a broken Venetian blind that was green, and he'd say, "Wow, that's amazing."

Lateral Pass, Trisha Brown Dance Company, sets by Robert Rauschenberg, music by Peter Zummo. Production photo by Luciano Romano 1986–1987

Barney Google Glut, 1987. Assembled metal collage, 38 x 77 x 17 in.

So, he was very selective, and the stage setting was so beautiful. He used a lot of everything. A lot of those Venetian blinds we put into the stage setting for Trisha's piece. He obviously had some sort of idea in mind that he was looking for, something unusual, because we hauled a big load of it back to the stage and worked all day all night setting it up. … It was just one of those amazing events to share. Very creative, very open.

Bill told another story that demonstrates Jasper Johns' continuing admiration for Rauschenberg's unique ability to see "junk" as artwork:

BG Rauschenberg and Johns were so together at one point in their lives because they thought so much alike. But when it comes to work, work is different. I remember when Bob started the *Gluts* series (illustrated above) he had a show downtown at Leo (Castelli, in 1986). I had a studio downtown, and we were in that studio working with Jasper on the *Season* prints (1985–86) when Jasper said, "I'm not going to have lunch with you guys. I'm going over to Leo's to see Bob's show."

I remember him coming back an hour later and saying, "God, I wish I could work like that." The show was those *Glut* pieces, that bright orange metal stuff that he had, that was bent all out of shape. And I mean there were some amazing pieces there, I will say, that were just junk at one point, and then Bob brought them into a—he raised their level of awareness!

Printmaking: Captured Moments

In Bill Goldston's mind, the special chemistry around Rauschenberg, Jasper Johns, and Jim Rosenquist in the late 1950s and '60s had a lot to do with their shared interest in capturing the image as experience, and the special capacity of printmaking for fueling that process:

BG The one thing I can say concretely about printmaking is that the moment Bob Rauschenberg makes a transfer, Jasper Johns makes a mark, Jim Rosenquist puts out an image—that is a recording device. It is a *captured moment*, which will never exist again. Neither Bob nor Jasper nor Jim will be that same person. One minute later they will have learned something from the mark itself. They will have learned something from the observation of the environment. They will not be the same person, but they will always be able to relate to that person because it's captured on that surface, that printing surface.

And this is the great thing that painting and drawing does not have—that *that moment* is only the beginning of something, and it can be used in many, many different ways. Because printmaking can be realized as a lithograph, as an etching, as a woodcut, as a silkscreen. And if the drawing is originally in graphite or black, that can be green or brown or red, it can be a part of another drawing, and it can be part of another thought. All of that can be added and taken away for endless times and for endless years. And not just today, but I mean if you found a lithographic stone from Alois Senefelder, who invented lithography in 1796, you could still print that stone.

DJ You keep returning to the idea that images capture a moment, a moment of consciousness they could repeatedly revisit.

BG They all (Johns, Rauschenberg, Rosenquist) realized that once they captured that image, then they could proceed to develop it. And Bob did that a lot in the early years. How he used those images again, and how Jasper took a stone and reworked it ten times to make ten different images, three different editions. I mean … those were very astute ways of working with printmaking.

On the *Lotus* series
Near the end of our discussion, Bill shared with me some details of how he came to propose his final collaboration with Rauschenberg, whose health was failing. The resulting works formed the Lotus *series, completed shortly before the artist's death in 2008:*

BG It was in the latter years of Bob's life and Darryl Pottorf got in touch with me. He said, "The boss needs a project." This was well after Bob lost the ability to use his right arm. So I called Bob and I said, "Hey, I got an idea here, this gallery in the 798 Art Zone wants to do a show of U.L.A.E. prints in Beijing. Would you be interested if we just make a Rauschenberg show in 798?" … There was a pause on the phone and he said, "Well, do you think they want new images or old images?"

New images would have meant that he or somebody would have had to go there and photograph, so I said, "Well, Bob, I think they'd take anything that you would give 'em. I mean, let's just work with whatever you want to work with."

Well, he had a pack of photographs … he and Don Saff had made in '78, '79 for the *Seven Characters* series. … And then when we got back to Beijing again in '85, Bob went around taking more pictures. So when he came back he did the *Summerhall* photographs with Don and he did some paper-making for Gemini. But he still had all these photographs wrapped up with rubber bands in a desk drawer. Somehow they had just discovered them.

Laurence Getford … scanned them and we reconstructed the color. And so Bob had at his disposal about 250 images, but it was hard for Bob to work because he was in a wheelchair and the way he worked was on big tabletops, and these tabletops could be 10 foot by 20 feet, you know, you can lay everything out.

Goldston then describes a process that he and Rauschenberg had developed about a decade earlier for a series entitled Ground Rules *(1996–97) that creates gestural, watercolor-like washes in the resulting prints (p. 23). As he explains, his adaptation of that method enabled Rauschenberg to work on a smaller scale:*

BG Bob called me and he said, "You know I can't work on the table the size I want to." And I said, "You make them any size you want to, but then you let me make them the size *I* want to!" I was supposed to go down to Rauschenberg's studio in Florida to work on it but when we went over to the studio he had already finished all eleven or twelve of them! And they were so beautiful. I had tears in my eyes just looking at all of them. He had them all lined up on the floor for me.

He had just completed a series of paintings … called the *Runts*. So I took one of the dimensions of the *Runts* and I made that dimension the larger dimension of the prints. That's how I arrived at the size of the *Lotus* series. I blew it all up to that size, sent him a proof.

He had put a lotus image in all of the pictures because of its significance in the Chinese culture … When I blew it up, I cut it out and said, "I'm just going to make that a photogravure plate." This was a surprise for him. That's the way you got him going. You threw something at him that he wasn't expecting. And so I proofed the first one. We made a plate and the guys here figured out a way to cut the plate out so they could follow the contour of the lotus.

The originals were transfers, they were different colors. But I figured we could … just tap in a little color … and buff it right into the plate, … so what we got him was this beautiful rendering of this image and this embossed surface, with the lotus plant. Well, he flipped out. He said, "Bill, this is the most beautiful thing I've ever done." I said, "Okay, we can talk about that one." But he said, "I love this. I don't want to frame it. I want it to look just like my paintings. …"

So, that became how the *Lotus* was finished. All of them were printed and mounted on Reynobond and framed just like his paintings are. It's one of the most beautiful groups of prints. I have one hanging in my dining room right now. I've kept it there ever since he passed away.

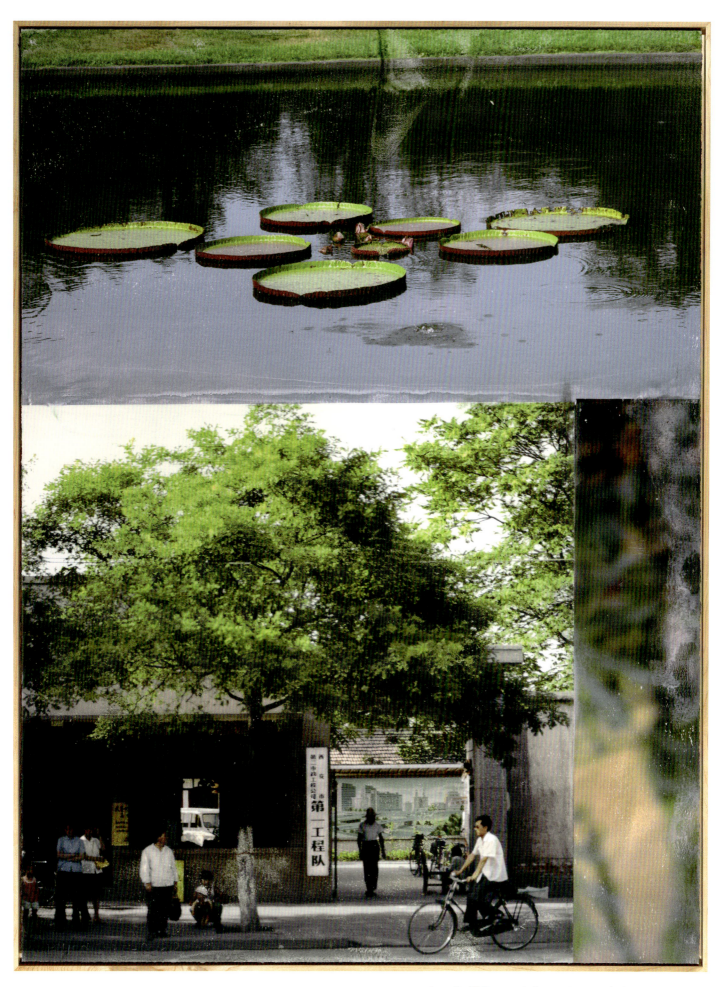

Lotus Bed II (*Lotus* series), 2008. Pigmented ink-jet, 60¾ x 45¾ in.

More Reflections

A final selection of works on metal surfaces display the artist's deep engagement and fascination with the role of the viewer in the artwork. Often heavily obscured—almost veiled—by screen-printed images, these works beg for active viewing. Reflections of the surroundings flicker in and out of view, and images appear alternately in positive and negative as backgrounds change. Often, the movement of the viewer is mirrored by the suggestion of travel or mechanical motion in the observed scene (baby carriage, bicycle, factory). Occasionally, Rauschenberg issues a direct invitation to interact, as when he incorporates a "seat" in *Borealis Shares II* (following pages).

Right: *Manhattan Ride* (*Galvanic Suite*), 1988. Acrylic on galvanized aluminum, 48 x 36 in.

Below: *Onyx I*, 1991. Acrylic on enameled aluminum, 37 x 49 in.

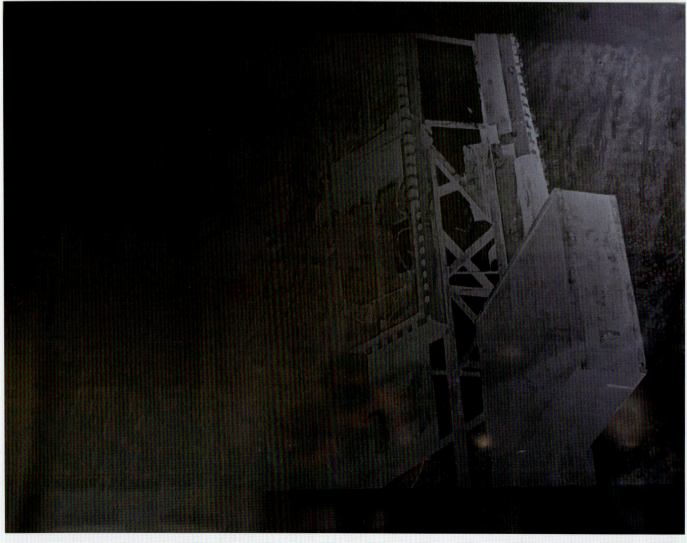

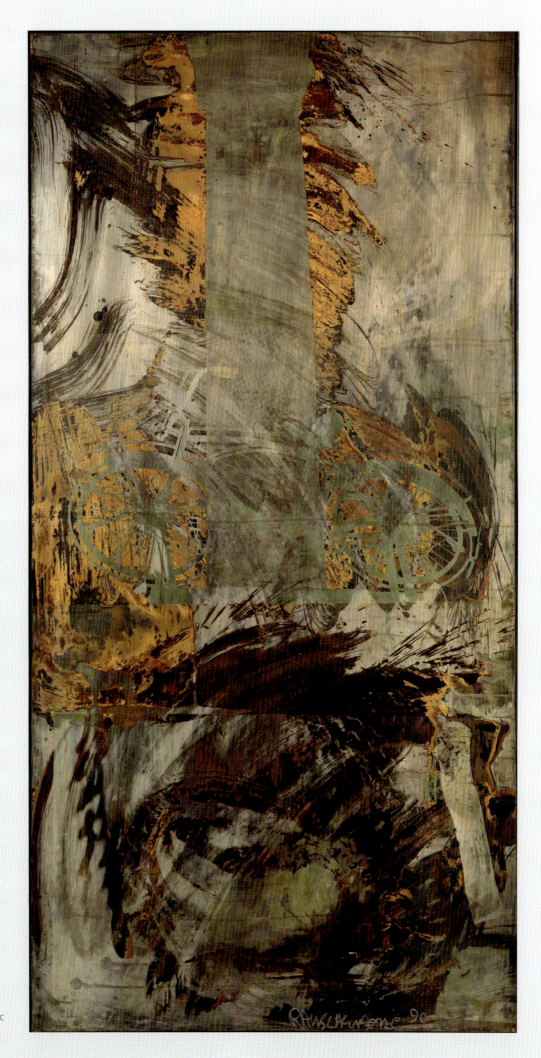

Anchored (*Borealis* series), 1990. Acrylic and tarnishes on bronze, 48 x 96 in.

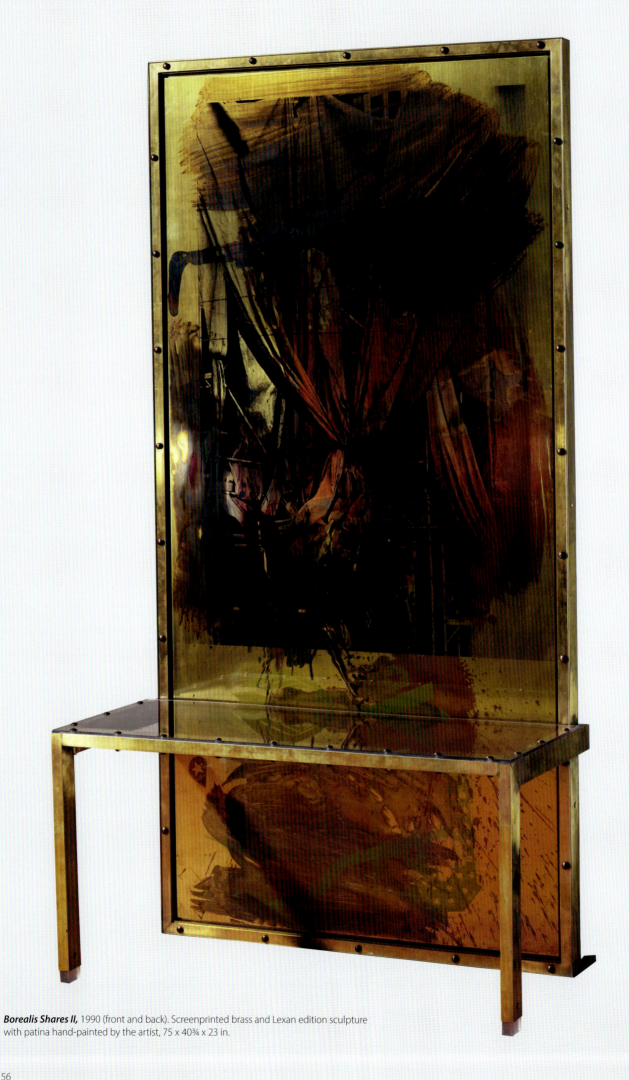

Borealis Shares II, 1990 (front and back). Screenprinted brass and Lexan edition sculpture with patina hand-painted by the artist, 75 x 40¾ x 23 in.

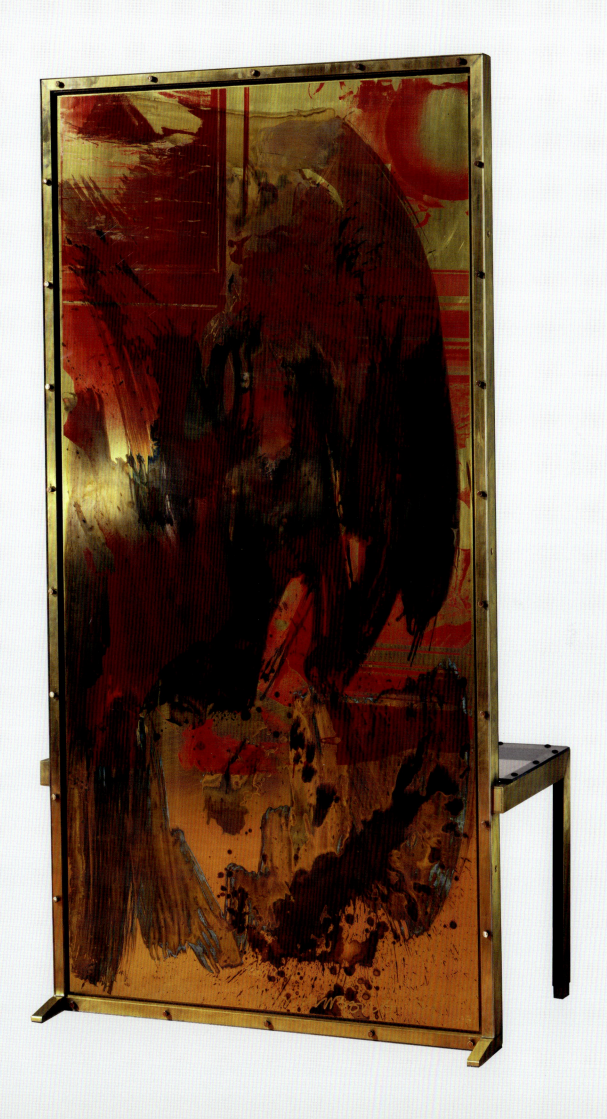

EXHIBITED ARTWORKS/CREDITS

Abby's Bird, 1962. Color lithograph from three stones on white wove paper, 19¾ x 13¹³⁄₁₆ in. Edition of 50, published by Universal Limited Art Editions. Collection/image courtesy of Universal Limited Art Editions **p. 19**

Accident, 1963. Lithograph, 41⁵⁄₁₆ x 29½ in. Number 24 from an edition of 29, published by Universal Limited Art Editions. Collection of Lily Appelman & Eugene Heller. Photograph by William O'Connor **p. 20**

Anchored (Borealis series), 1990. Acrylic and tarnishes on bronze, 48 x 96 in. Private Collection. Garth Francis Photography **p. 55**

Autobiography, 1968. Offset lithograph, 198¾ x 48¾ in. Edition of 2000, published by Broadside Art, Inc. Illustrated version courtesy San Francisco Museum of Modern Art; Gift of Marian B. Javits, Robert Rauschenberg, and Milton Glaser. © Robert Rauschenberg Foundation. Photograph by Ben Blackwell. Exhibited version: Collection of Museum of Outdoor Arts. **pp. 4–7**

Back-up (Ground Rules series), 1997. Intaglio in 5 colors with photogravure, 57½ x 49⅝ in. Edition of 44 (Trial Proof), published by Universal Limited Art Editions. Collection/image courtesy of Universal Limited Art Editions **p. 23**

Barney Google Glut, 1987. Assembled metal collage, 38 x 77 x 17 in. Private Collection. Garth Francis Photography **p. 51**

Bedlam (Waterworks series), 1992. Vegetable dye transfer on paper, 41¾ x 29½ in. Private Collection. Garth Francis Photography **p. 17**

Big and Little Bullys (Ruminations series), 1999. Photolithograph, 46¹⁄₁₆ x 58⅛ in. Edition of 46, published by Universal Limited Art Editions. The Madden Collection, University of Denver. Photograph by William O'Connor **p. 8**

Borealis Shares II, 1990. Screenprinted brass and Lexan edition sculpture with patina hand-painted by the artist, 75 x 40¾ x 23 in. Series of 26 unique works published by Gemini G.E.L. Illustrated version © 1990 Robert Rauschenberg and Gemini G.E.L. Version exhibited: The Madden Collection, University of Denver **pp. 56–57**

Cliché Verre, 1980. Offset and lithography on acetate, 25 x 18⅝in. Edition of 250, published by The Drawing and Print Club Founders Society, Detroit Institute of Art. Private Collection. Garth Francis Photography **p. 59**

Cock-Sure, 1993. Screenprint, firewax, pigment on paper and Lexan, 59¾ x 40⅛ in. No. 17, edition of 17, produced in collaboration with Saff Tech Arts. Private Collection. Garth Francis Photography **p. 16**

Crowing (Urban Bourbon series), 1991. Acrylic on mirrored aluminum, 79 x 97 in. Private Collection. Garth Francis Photography **p. 59**

Darkness Mother, 1978. Color photolithograph and lithograph from three stones on cream wove paper, 28 x 20 in. Edition of 41, published by Universal Limited Art Editions. Collection/image courtesy of Universal Limited Art Editions **p. 25**

Eagle Eye (Ruminations series), 1999. Photolithograph, 49⅝ x 37¹⁵⁄₁₆ in. Edition of 46, published by Universal Limited Art Editions. The Madden Collection, University of Denver. Photograph by William O'Connor **p. 10**

Echo When, 1978. Color photolithograph and lithograph from three stones on cream wove paper, 28 x 20 in. Edition of 41, published by Universal Limited Art Editions. Collection/image courtesy of Universal Limited Art Editions **p. 24**

Robert Rauschenberg with **Autobigraphy** at the Whitney Museum, ca. 1968. Image source: press release, Broadside Art Inc. Collection SFMOMA

Cliché Verre, 1980. Offset and lithography on acetate, 25 x 18⅝ in.

Below: *Crowing* (***Urban Bourbon** series*), 1991. Acrylic on mirrored aluminum, 79 x 97 in.

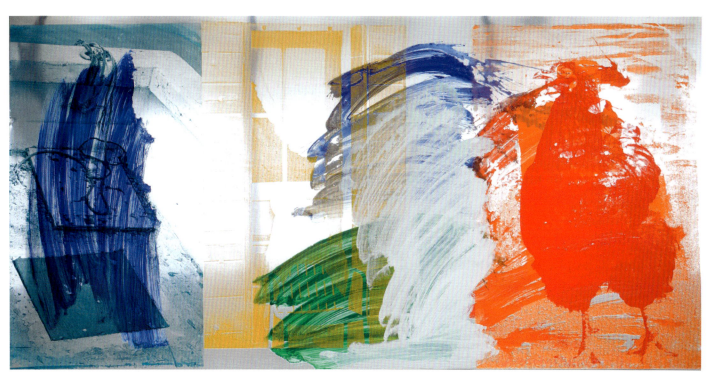

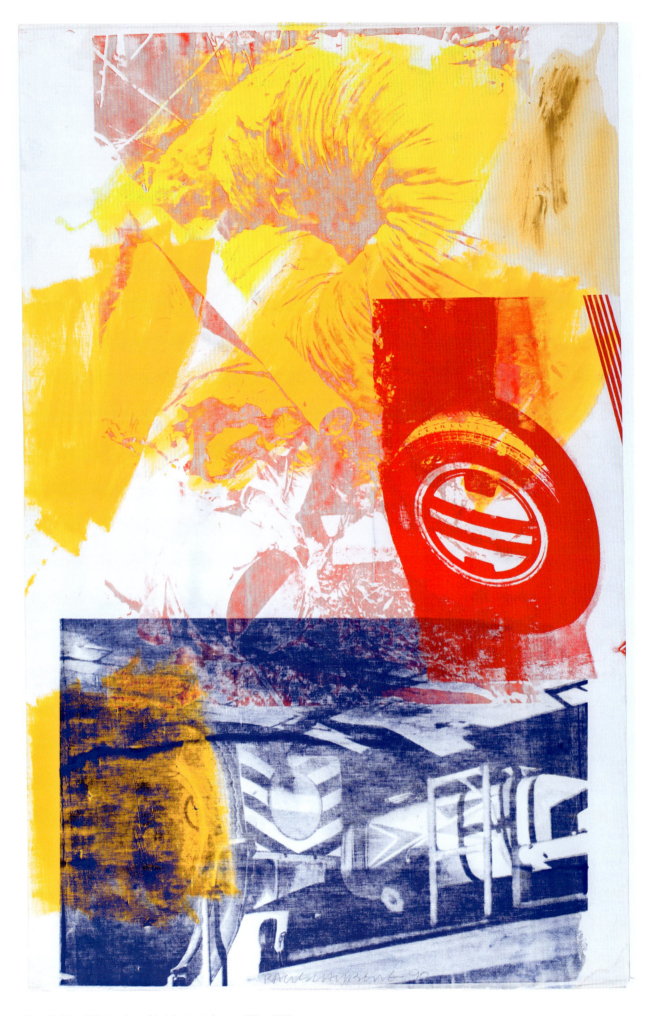

Extra Knight, 1990. Acrylic on fabric laminated paper, 63½ x 40¾ in.

Extra Knight, 1990. Acrylic on fabric laminated paper, 63½ x 40¾ in. Private Collection. Garth Francis Photography **p. 60**

Hog Chow (***Chow Bags*** **series**), 1977. Screenprint on paper with collage, 48⅛ x 36⅜ in. Edition of 100, published by Styria Studios, New York. Gift from the Collection of Mr. and Mrs. Aaron B. Katz, CU Art Museum, University of Colorado Boulder **p. 47**

Howl (***7 Characters*** **series**), 1982. Silk, ribbon, paper, paper-pulp relief, ink, and gold leaf on handmade Xuan paper, with mirror, framed in a Plexiglas box, 43 x 31 x 2½ in. Series of 70 unique works, published by Gemini G.E.L. Collection of Lily Appelman & Eugene Heller. Photograph by William O'Connor. **p. 28**

Ileana (***Ruminations*** **series**), 1999. Intaglio, 26¾ x 31¼ in. Edition of 46, published by Universal Limited Art Editions. The Madden Collection, University of Denver. Photo by William O'Connor **p. 11**

In Case You Need a Hand, 1995. Solvent transfer, acrylic and collage on paper, 11 x 8¼ in. Private Collection. Garth Francis Photography **p. 13**

Jap (***Ruminations*** **series**), 1999. Photolithograph, 19¾ x 26 in. Edition of 46, published by Universal Limited Art Editions. The Madden Collection, University of Denver. Photograph by William O'Connor **p. 9**

John (***Ruminations*** **series**), 1999. Photolithograph, 29½ x 38¹³⁄₁₆ in. Edition of 46, published by Universal Limited Art Editions. The Madden Collection, University of Denver. Photograph by William O'Connor **p. 9**

Lithograph I (***Glacial Decoy*** **series**), 1979. Lithograph in 5 colors, 32 x 48 in. Edition of 28, published by Universal Limited Art Editions. Collection/image courtesy of Universal Limited Art Editions **p. 14**

Lotus Bed II (***Lotus*** **series**), 2008. Framed pigmented ink-jet, 60¾ x 45¾ in. Edition of 50, published by Universal Limited Art Editions. Collection/image courtesy of Universal Limited Art Editions **p. 53**

Lotus II (***Lotus*** **series**), 2008. Framed pigmented ink-jet with photogravure, 45¾ x 60¾ in. Edition of 50, published by Universal Limited Art Editions. Collection/image courtesy of Universal Limited Art Editions **p. 37**

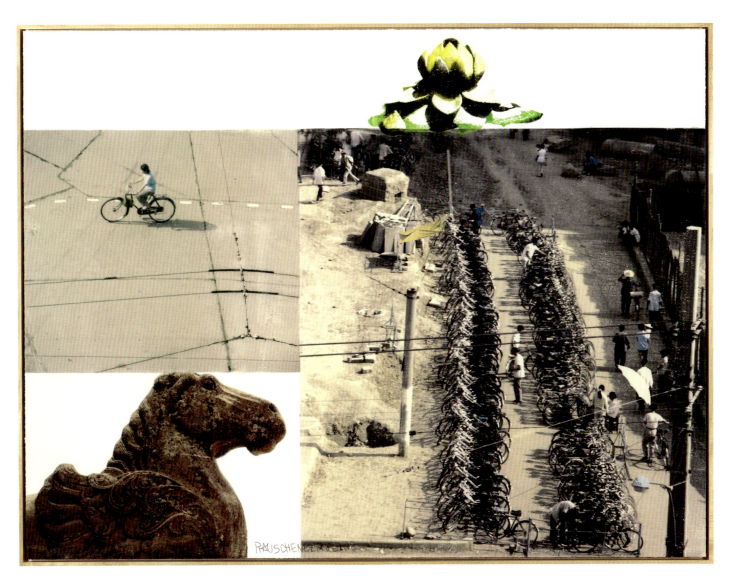

Lotus VI (*Lotus* series), 2008. Pigmented ink-jet with photogravure, 45¾ x 60¾ in.

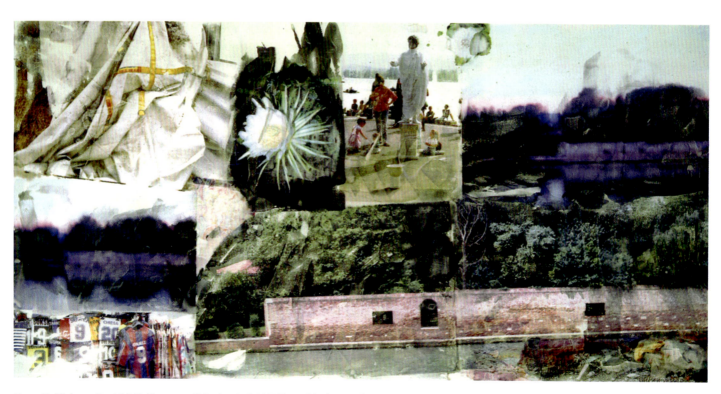

Monastic Birdsong Duet 5 A.M. (*Anagram (A Pun)* **series**), 1997. Vegetable dye transfer on polylaminate, 61 x 124 in.

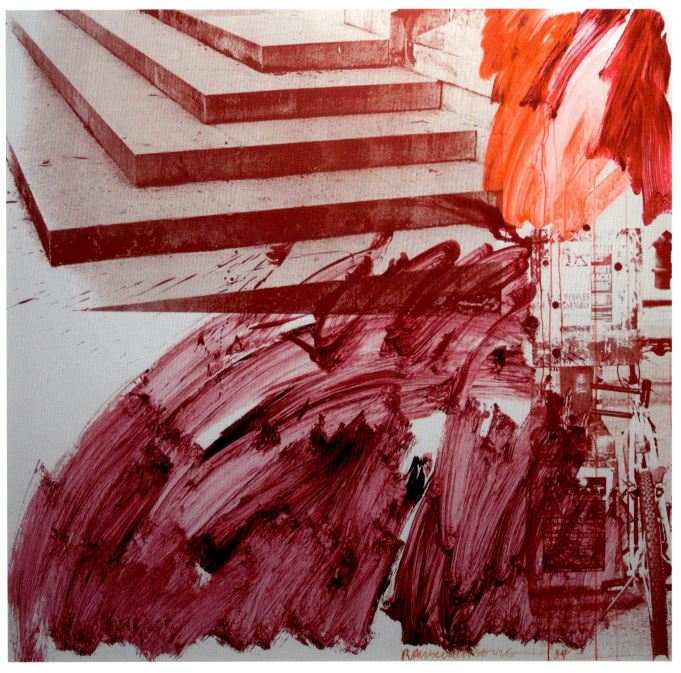

Ruby Climb, 1994. Acrylic on aluminum, 60 x 60¼ in.

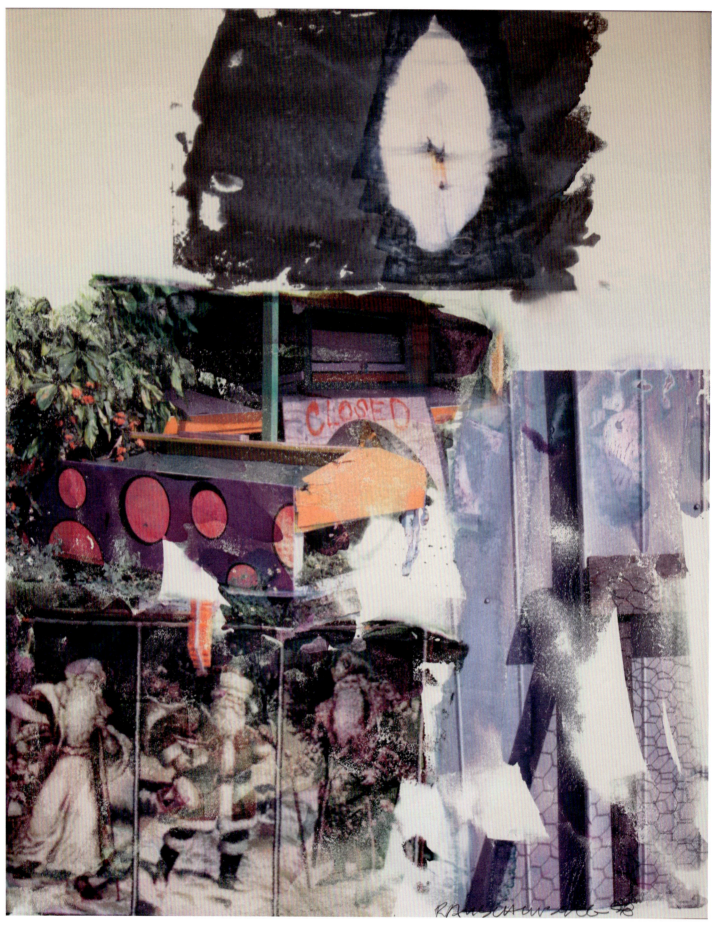

*Twas (**Anagram (A Pun)** series)*, 1998. Vegetable dye transfer on polylaminate, 61 x 49½ in.

Opal Gospel, 1971. Silkscreen ink on ten Plexiglas sheets with base and stainless steel cover, 21 x 23 x 7 in.

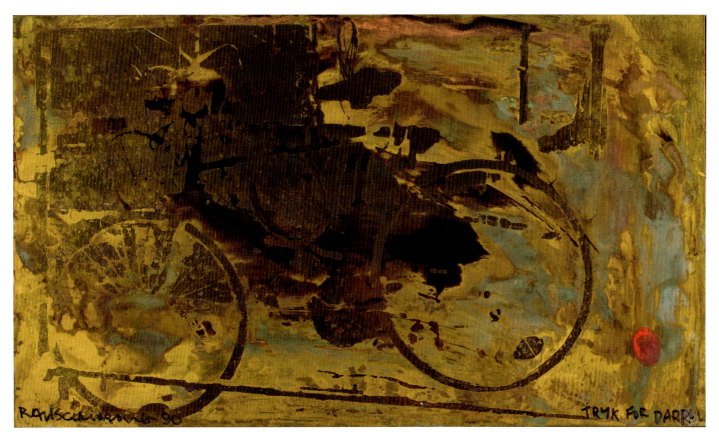

Tryk for Darryl (**Borealis** series), 1990. Acrylic and tarnishes on bronze, 14 3/8 x 24 3/8 in.

CATALOG CONTRIBUTORS

Sienna Brown, PhD
Independent curator Sienna Brown formerly served as the Curator of Modern and Contemporary Art at the Philbrook Museum, Tulsa, where her projects included exhibitions of Christopher Wool and of Chicano art from the collection of Cheech Marin. Dr. Brown has written about Mel Bochner and printmaking, and about Robert Smithson and vision science. She received her undergraduate degree from The University of Chicago and her PhD in Art History from Emory University in Atlanta, where her dissertation was a deep exploration and catalogue raisonné of Robert Rauschenberg's lithographs.

Hiroko Ikegami, PhD
Hiroko Ikegami, associate professor at the Graduate School of Intercultural Studies of Kobe University, specializes in post-1945 American art and global modernisms. Her main publications include *The Great Migrator: Robert Rauschenberg and the Global Rise of American Art* (The MIT Press, 2010) and *International Pop* (Walker Art Center, 2015). In 2016, she received the prestigious Suntory Prize for Social Sciences and Humanities for the Japanese edition of *The Great Migrator*. She is also a founding member and vice director of Oral History Archives of Japanese Art, an organization devoted to conducting interviews with individuals involved in the field of art in Japan, and making the transcripts available on line as historical documents. She received her PhD from Yale University.

Dan Jacobs
Independent curator and consultant Dan Jacobs expanded his career as a museum curator and leader by establishing Dan Jacobs Associates in 2018. He has served in senior positions at the Denver Art Museum and the Getty Conservation Institute, and as founding curator of the University of Denver Art Collections, where he established a fully-equipped Art Study Center to support research and teaching directly from on-site holdings of more than 3000 works. His consulting includes curatorial projects at the Timken Museum of Art in San Diego, museum planning work with Hal Fischer Associates, and engagements serving major private collections. He received his bachelor's degree from Harvard College, his MBA from UCLA and an MA in Art History from the University of Colorado, Boulder.

Cynthia Madden Leitner
Cynthia Madden Leitner is the founder and President of the Museum of Outdoor Arts (MOA), Colorado. In 1995 she was awarded the Colorado Governor's Award for Excellence in the Arts for the realization of MOA's unique vision, and has been selected for the Denver Mayor's Commission of Arts, Culture, and Film. In 1999 she co-curated *A View from Denver*, a collaboration with the Denver Art Museum for the White House Rose Garden. In 2010 MOA debuted its off-the-grid home and exhibition, *Element House*, the designs for which have been accessioned by the Museum of Modern Art. During her tenure she has curated over 200 exhibitions, and has worked with renowned local, national, and international artists. Serving on numerous boards, she is also an Honorary Trustee of The Women's Foundation of Colorado, and a founding member of the National Museum of Women in the Arts.

Sarah Magnatta, PhD
Sarah Magnatta is an independent curator and exhibition consultant based in Denver. She received her PhD in Art History from The Ohio State University with specializations in South Asian, Himalayan, and Contemporary Art, as well as in Museum Studies. She has taught in the School of Art and Art History at the University of Denver since 2010. At the Denver Art Museum she served as an interpretive specialist and was also a board member of the museum's Asian Art Association, hosting international artists Gonkar Gyatso, Tsherin Sherpa, and Tenzing Rigdol as guest speakers. She is currently on the Museum Committee for the College Art Association (CAA), and is active as an independent curator, with recent projects in Denver and in New York City at Tibet House.

*Untitled (**Ruler/Twine**)*, 2008. 12-inch wooden ruler balanced on ball of twine. 4⅛ x 11¾ x 3¾ in.

Speaking in Tongues: **Own Your Own Rauschenberg**

Recalling his earlier experiments with user-driven, configurable printed sculptural discs and plates in large-scale works like *Revolver*, *Passport*, and *Shades*, Rauschenberg continued to go smaller in pieces like *Opal Gospel* (p. 65), created in larger numbers and at a lower price. He went a step further with the format in his 1983 design of a translucent special edition LP of the Talking Heads' hit album, *Speaking in Tongues*. By designing a piece that could be mass-produced and purchased by thousands of consumers, Rauschenberg brought the concept of collaborative art directly into consumers' homes. It is still possible, over 45 years after the release of this special edition, to buy a copy for less than $50.

Below and following pages: *Speaking in Tongues*, 1983. Printed translucent vinyl LP record, 3 translucent plastic inserts, all 12 in. diameter, and clear plastic album cover, 13 x 13 x ¼ in.